Art & Soul

ALSO BY AUDREY FLACK

Audrey Flack on Painting

Art & Soul

NOTES ON CREATING

AUDREY FLACK

ARKANA

ARKANA

Published by the Penguin Group
Penguin Books USA Inc.,
375 Hudson Street, New York, New York 10014, U.S.A.
Penguin Books Ltd, 27 Wrights Lane, London W8 5TZ, England
Penguin Books Australia Ltd, Ringwood, Victoria, Australia
Penguin Books Canada Ltd, 10 Alcorn Avenue,
Toronto, Ontario, Canada M4V 3B2
Penguin Books (N.Z.) Ltd, 182-190 Wairau Road,
Auckland 10, New Zealand

Penguin Books Ltd, Registered Offices:
Harmondsworth, Middlesex, England

First published in the United States of America by E. P. Dutton 1986
Published simultaneously in Canada by Fitzhenry & Whiteside, Ltd., Toronto
Published in Arkana 1991

3 5 7 9 10 8 6 4 2

ISBN 0 14 01.9347 2

Printed in the United States of America

Designed by Mark O'Connor

My deepest thanks and appreciation to Jane Lahr for that spark of enlightenment and encouragement which generated this book . . . to the poet Hugh Prather and the artist Robert Henri, whose books inspired me . . . to Diane Burko, who spent many hours reading my notes with an artist's eye and a clear mind . . . to Renée Lipson, my dear friend, who discussed, typed, corrected, and assisted in completing this book . . . and to Joyce Engelson, my editor, for her assistance in developing the book with me, for her brilliance as an editor, and for her friendship . . . and, last and most important, to all of my artist colleagues, past, present, and future, without whom this book could not have been written.

CONTENTS

CONVERSATIONS WITH ARTISTS: PERSONAL STORIES AND PARABLES

MYTHS AND THE SPIRIT

ART AND SOCIETY

STUDENT / TEACHER

JURYING FOR THE
NATIONAL ENDOWMENT AWARDS

CREDO

I believe in art.
I do not believe in the "art world" as
it is today.
I do not believe in art as a commodity.
Great art is in exquisite balance. It is
restorative.
I believe in the energy of art, and through
the use of that energy, the artist's ability
to transform his or her life and, by ex-
ample, the lives of others.
I believe that through our art, and through
the projection of transcendent imagery, we
can mend and heal the planet.

—From commencement address delivered at
the Pennsylvania Academy of the Fine Arts,
May 1984, by Audrey Flack

WHAT THIS BOOK IS ABOUT

This is a collection of thoughts and experiences, and sometimes my responses to them, garnered through the years, in the hope that they will identify and record the shared but often unspoken knowledge among artists.

When I say "artists," I mean poets, writers, musicians, and dancers, as well as painters and sculptors. You can substitute the words that suit your own life.

Once artists understand the underlying structure of their own field, that information can assist in the understanding of all other creative fields. Once having completed a large, complex painting, for instance, it would be far easier to understand the complex structure of a long, intricate novel.

These notes have not been designed to be read as a regular book, from cover to cover, but rather to be picked up at any time and opened to any page, to offer comfort and nourishment in a difficult art world.

Sometimes I am trying to get at the node of creativity itself, and sometimes I need to talk about those aspects of the art world that inhibit creativity.

I expect many of the pages will confirm ideas already held by artists working in isolation. I hope others will suggest and stimulate new thoughts and ideas.

There are repeats and overlappings—a viewing of the same thoughts from different angles. And there are places in which I have contradicted myself in an effort to explore all sides of an issue.

Sometimes my insights into the art world, good or ill,

may not be yours. We can't all agree with each other over every issue; I'll be pleased if any of my statements stimulate new ideas, challenge old ones. If they appear provocative, however inadvertently, that will serve a purpose also.

IN AND AROUND
THE STUDIO:

ATELIER OF
THE ARTIST'S MIND

ART IS A CALLING

Art is a calling. Artists are not discovered in school. Artists do not just paint for themselves, and they don't simply paint for an audience. They paint because they have to. There is something within the artist that has to be expressed. Every creation reveals something more about the universe and about the artist.

Some artists surface earlier than others, but all are born to the calling.

We share a common language and a common love of our masters, and although we often take issue with one another, we are all family.

DESTINY

When you are working, you are alone with yourself. You get in touch with your own destiny. Like entering a dream state, the tendency is to disbelieve that that state has validity. But that is the true reality.

ARTISTS AND ATHLETES

Like athletes, artists must be in excellent physical shape in order to create their best works. Artists stand when they paint, walking back and forth hundreds of times a day during the painting process.

Action comes not from the wrist alone, but from the entire painting arm. Like an elegant fencer, with one arm forward and the other behind the back, the entire body is put into motion. Abstract expressionists knew this; that is why they were called "action painters."

SEEING LARGER OR SMALLER THAN LIFE

Artists see in specific sizes: larger than life, smaller than life, or life size, whatever that is. It's like choosing a camera lens. Richard Estes prefers 55 mm, 35 mm, and wide-angle lenses, which reduce objects and clarify by sharpening and including a broader scope of the landscape.

I have always preferred 85 mm or 105 mm lenses, which bring objects up close and clarify by enlarging. When working on large-scale paintings, I use high-powered enlarging lenses, with a Leitz 2¼-inch slide projector. I stand in front of these huge projected images, and through some illusionary fusion, I become a part of them. Sections of the slide are projected right onto my back while I work; the rest falls onto the canvas. The images surround me, and I

sometimes feel lost in their world, examining their structure and intimate detail.

Long before I used a camera, my vision was 85 mm. I remember early still-life paintings, where I was always surprised to notice either halfway through or after completion that the size of the oranges or apples was exaggerated and slightly larger than life.

Rembrandt saw larger than life.
Van Dyck—larger.
Rubens—larger.
Vermeer, Pieter de Hoogh (the Dutch genre
 painters)—smaller.
Michelangelo—larger.
Leonardo—middle to smaller.
Renoir—larger.
Gerard David—smaller.
Rogier van der Weyden—smaller.

DISTANCE

There is a distance at which artists want their work to be seen. When it comes into focus, that distance correlates with whether the artist sees larger or smaller than life.

INTIMACY

Small paintings are supposed to be intimate. Yet I heard Rothko say that large paintings were intimate for him because when he went up to them, he felt engulfed by them. Both large and small can be intimate.

WHEN IS A PAINTING
FINISHED?

A painting absorbs and absorbs and then it reaches a saturation point. The artist has to be keenly aware of that moment and stop. If one continues beyond that point, the painting gets muddy and clouded over. Until that point, it can be completed many times, depending on how the artist wants it to look: dense or airy, loose or tight, free or controlled. The artist chooses to stop at any one of these times.

In great works of art there is only one optimum completion. As in filling a glass drop by drop, when the glass is full, it takes only one extra drop to cause a spill, one less to create perfection.

TITLES

The title affects the work. If a painting is titled during the early configuration of it, the sense and meaning of the title become part of the painting.

Some titles just appear; they seem to be woven into the structure of the composition. Others are elusive and only emerge through struggle, battle, or debate. Some works never get a name; others get two.

THE EGO

If you build a stage set for the ego, it becomes a fortress. In a fortress, transformation is impossible. You have isolated yourself, and the intimacy that assists transformation is not there.

In this way, by the time you reach old age, you have concretized and solidified the ego, and your paintings cannot change nor move.

A "successful" style gets repeated to satisfy the ego's demand for attention and sales. The ego is always thirsty and hungry. It should be left outside the studio door.

EXPERIENCING THE POETICS
OF PAINTING

There is a distinction between those artists who produce marketable images, and then produce variations for that market, and those who have resisted market pressures. One stops the flow, while the other allows growth to take place. This process of growing occurs during a total involvement in the creative act. You are not just producing images, but provoking and being provoked by those images. You get involved in a metaphoric revelation, and witness metaphors emerging from the work.

The energy output in your body slows down and your fingertips cool as you contemplate your own production— a dialogue between you and your work; a total retinal involvement—until you become mesmerized and see all kinds of presences in the work.

This is the essence of the act of painting and what painting ought to be about. The ultimate achievement is a transference of that revelation from private to public.

—From a talk with Robert Slutzky,
February 20, 1985

THE ACT OF PAINTING

It almost doesn't matter what you paint. It is what takes place during the act of painting that matters.

It doesn't matter what style or technique you use. It is the artistic result and personal development that count.

The act of painting is a spiritual covenant between the maker and the higher powers. The intent of the artist flows through the work of art, no matter what the technique or style.

DREAM TIME

The element of time in the creative process is similar to dream time. It stretches and contracts as you work. You can work on something for weeks and weeks and nothing will happen, and yet something can transpire in only an hour. The last five minutes of dream time can process data of epic proportions, and yet one needed the entire night's sleep to arrive at the dream images.

PERCEIVING COLORS

We see colors differently. I see blue hues with one eye, my right, and warm yellow tones with my left. I've found that many artists see this way. I believe this is a function of a highly developed color sense.

THERE ARE NO RULES

Yellow is supposed to come forward. Blue is supposed to recede. I can easily reverse the two.

THE BLANK CANVAS

It can be terrifying to confront a blank canvas—is it a fear of destroying it?

You are about to create a world in this pure and empty space, a world in which complex goals have been set. In one way you have become God; in another way you know you are not.

It becomes a courageous act to make a mark on that canvas. Once the mark is made and the initial anxiety overcome, a tension is set up on the canvas; a dialogue between you and your work is now possible.

The intellect and emotions have been acted upon and transferred to the canvas. The macrocosm of life has now been synapsed in the microcosm of the artist's confrontation with the canvas.

MISTAKES

When you make a mistake and take it out, you can't just leave it; you have to get the painting back into some kind of shape, in order to work on it the next day.

Mistakes have a biology, they are not simply erased. The erasing of the mistake, words or paint, doesn't return the space to a blank.

FAST AND SLOW

There are times to work rapidly and times to go slowly. In the beginning one sets a fast pace, blocking it in, pushing the paint or clay around—large forms, areas of color. Later on in the work, one makes subtle refinements—details, smaller forms—the pace slows down and a meditative state takes over.

When all parts of the work start coming together, a renewed excitement is generated and builds until the harmony and balance of what you have been trying to accomplish work. You feel like a conductor bringing the full sound of an orchestra to its grand finale. You have reached the peak experience toward which all artists work. It is at these times you can see me buckdancing, clogging, discoing, and Indian tribal dancing around my studio.

WORK CLOTHES

When I work, I can't wear intense colors. I become a vehicle, a channel; any strong color, clothing style, or hairdo stimulates the ego and acts as an interference.

I own two pairs of painting pants. One is an old favorite, patinaed with several years of accumulated paint, and the other is a backup pair that is gradually being broken in as a replacement.

All the clothing must fit comfortably and not be restrictive in any way. Long sleeves can't be baggy, or they hamper action and freedom.

Shoes are important; they must be comfortable enough that I can endure hours of standing, and have a spring to them so I can sprint around the studio.

For artists, particularly, clothes become a protective skin, providing a freedom to work.

STUDIO GHOSTS

When you're in the studio painting, there are a lot of people in there with you. Your teachers, friends, painters from history, critics . . . and one by one, if you're really painting, they walk out. And if you're really painting, *you* walk out.

—From a talk with Philip Guston

VIBRATIONS

We actually receive vibrations from paintings. These vibrations emanate from colors. When we say we receive a charge from a work of art, it is not just psychological in nature. Physical properties are affecting us.

My experiments with color, light, and the airbrush affected the way I painted. I discovered that colors mixed in a dimly lit room, under a spotlight, which when held up to the canvas matched exactly the projected image color, were between five and ten shades off in a room that was fully lit. I began to premix my colors, storing them in film containers and jars. My thought process gradually changed. I began thinking in terms of light rather than color. I would select a pigment and apply it to a surface that I knew would reflect light. Conversely, if I wanted a dark, I would select a pigment with nonreflective qualities and apply it to an absorbent surface. In many cases the color of the pigment was secondary and I could pick any one of the many colors to achieve the desired effect.

—From *Audrey Flack on Painting*,
1981

LEVELS OF SEEING

When I'm working from a photograph, a transparency, or direct observation, I am always amazed at how much more I see as the painting progresses. After I think I have completely perceived a particular area, something else reveals itself. As the work continues, the level of awareness deepens. The process takes its own time. I have come to accept that time and not fight it. I know that when I begin my work, no matter how hard I try, I'll never observe as much on the first day as I will on the last. Like life, the development will not be rushed, nor will there be full realization before completion.

Dr. Leopold Caligor, a prominent New York psychiatrist, says that as he listens to tapes of recorded sessions with patients, he hears new things and gains deeper insights. Each time he listens, more information is uncovered. This process is repeated until understanding is complete.

ENERGY EXCHANGE

Paintings change after you paint them. They take on a different character once they are out of your studio and hanging in a gallery or museum. Of course, we change and our perceptions differ, but the actual structure of the painting changes also.

Visiting a painting after many years have elapsed is a revelation. It can appear to be smaller or larger, brighter or duller. This refers not just to my own works but also to old masters whose imprint I have carried in my brain for years.

The light that a painting is exposed to will affect the colors; they can blacken or fade. Pigments dry at different rates. The molecular structure and chemical composition of the paint can be in flux for many years; there can be constant, imperceptible movement beneath the layers of paint, causing crackles and fissures.

But there is another kind of change that comes from the direct focus of the eyes of the observers. This has an effect on the energy structure of paintings.

Werner Heisenberg, a Nobel Prize winner in physics, says that there is no such thing as the exact science. We cannot observe anything at that subatomic level without changing it. Whatever we see is subject to our method of questioning.

EXTENDING THE BOUNDARIES

I always wanted to draw realistically. For me, art is a continuous discovery of reality, an exploration of visual data, that has been going on for centuries, each artist contributing to the next generation's advancement. I wanted to go a step further and extend the boundaries. I also believe people have a deep need to understand their world, and that art clarifies reality for them.

<div align="right">—From my interview in Art Talk
with Cindy Nemser, 1974</div>

WHY DO I DO PORTRAITS?

Every few years I have an uncontrollable urge to paint portraits. There is an aspect of the human spirit that cannot be reached in any other way: a profound look at myself, through the camera, through the mirror, long and direct— a self-portrait. Always searching, trying to find out who and where I am at that particular time in my life, at that particular moment in the universe, trying to communicate the human condition, the universals in all of us.

I look for the aging process—changes in my eyes, lines on my face. Everything the eyes have seen is reflected in them. I try to paint that.

LIFE IS OF ULTIMATE IMPORTANCE

If the art world begins to destroy your life, give it up. Don't give up art.

THE INITIAL IMAGE

When you've worked at it long enough, you arrive at the point where you can make images that you always have known: images that you knew, as a child, were your own definition of art. These initial images came from your inner truth. They triggered an impulse to go into the field of art.

You then learn what the world tells you art is, and you become a "professional artist." Finally, with enough courage, discipline, detachment, passion, and resistance, you can temporarily put this volume of historical data and art information aside and reconnect with your initial impulse—that which you always believed. The thread of belief has been sustained.

Now can you blend all of the learned information with the inner image into the fact of your art.

You have now appropriated art. Until that point, art appropriated you.

—From a talk with Leonard Lehrer,
Arizona State University

CONSTABLE

Why are we drawn to particular artists at certain times in our lives? The feeling, character, and technique of an artist must fulfill a particular need at a given time. After many years of barely noticing Constable, his visions of nature have come vividly alive for me.

I have been painting watercolors of the East Hampton landscape for the past few years. I travel around with my Arches watercolor block, collapsible stool, and watercolor box, chasing sunsets, observing the seasonal changes, feeling the spray of the ocean, and smelling the fresh grasses.

When I see a cumulus cloud, I think of Constable and his wonderful sky studies. The clouds and topography of England are different from those of East Hampton, but Constable has become a companion and we share the joy of watercolor and nature together.

WHEN THE SCULPTURE COLLAPSED

After I had worked every day for one month on a four-foot statue, the armature suddenly broke. I watched in shock as a foot fell off . . . part of a hip . . . the gluteus maximus . . . one arm . . . a month of seeing, studying, analyzing forms and muscles. It was a baroque pose—the rectus abdominus twisted and extended from the upper right to the lower left of the torso. Half of the piece was lost. I felt ill.

My husband, Bob, and a visiting friend, Renée, held it up while I frantically tried to reinforce the armature, in order to salvage what was left of the piece. I put in an emergency call to Donald Kennedy, a sculptor and friend, who came like a doctor in the night. The intense heat of the past few August days, combined with the heat from the studio lights, had dangerously softened the clay. Donald arrived with ropes, hoists, blankets, wooden wedges for propping, and a giant toolbox filled with turnbolts, elbow joints, wrenches, and screws. We cooled the piece down with icewater and propped it up with wood, wire, and ropes. Thus it was stabilized until a new armature was built. The sculpture was now standing, partially salvaged. I couldn't work for several days; heartsick, I couldn't walk into the studio. When I was able to resume, I re-created the statue in three days. It had taken one month to understand the pose—to interpret the forms, the twists and curves, the muscle attachments, the skeleton. The time was spent in the struggle to see. That having been accomplished and

committed to memory, I could quickly reproduce the exact pose even without the model's being there.

The mind retains thoroughly comprehended information, and it can be called upon at any time.

A PERSONAL TEST

I've rejected the idea of working life-size or of using body casts for my sculpture. The enlargement or reduction in scale reaffirms its nature as an artifact; the sculpture is not just a replication. It has been particularly curious and difficult to reduce an adult model down to a four-foot height.

The struggle of my brain, in scanning the model and reducing the scale with no mechanical assistance, has been a test.

EMISSARY

I have been changing the contours of the face, draperies, headdress, and title of a new sculpture that I have been refining and reworking for well over a year now. She has carried projections of ancient mythological figures—Greek, Far Eastern, Indian, Tibetan, Chinese, and Japanese, as well as American Indian. What seems to be happening, in spite of myself, is a composite figure, a complement of all of them. I can't seem to help what's coming out. I call it *Emissary*.

Sometimes the artist is not the final control. She absorbs the basic tenets of the age in which she lives, creating an assemblage. This subconscious assimilation of the flavor of the age, combined with archetypal concepts, is poured out in the form of art.

THE GEM AND THE GIANT

Grandiosity is part of our moment. We worship big things. If it's big, it's good; if it's little, it's no good. Large scale, impact, and extravagance are prerequisites.

I told Howard Wooden that I wondered why I was working small-scale, particularly since I know that I see larger than life and it is natural for me to work on a large scale. And why sculpture, after a lifetime of painting? Yet I am overcome with an insistence that goes beyond myself. I must make sculpture now. The art world and the world outside of it seems to be going haywire—out of control, structureless, oversized, and temporary. I need the substance of sculpture, the compactness of scale reduction in the form of a recognizable human figure—something solid, real, tangible. Something to hold and to hold on to. Something that won't fly away or disintegrate. Bronze, heavy-weighted, yet portable. I want people to be able to own these pieces as well as exchange them. My fantasy is to be able to produce them in great numbers, large editions, inexpensive, affordable—votive figures, some to be left as markers, some to be kept and carried with their owners.

Another part of the vision is to use some of these small sculptures as maquettes for larger-than-life-sized single figures, to be placed outdoors at significant sites. These would act as beacons or markers.

The Apollo Marcellus gem, housed in the fifteenth-century Lorenzo de Medici collection, dates back to the time of Nero. Carved gems and small objects were the channels of influence of antiquity into the Renaissance, because they were small and could readily travel along with migrant populations.

Howard Wooden says he notices that many artists are beginning to work small, voicing feelings of imminent destruction and change. These too are times when politically disrupted societies and cultural change are manifested in migrations of populations.

If that is so, it would explain the reduction in scale that seems to be occurring among many artists who are not just reflecting the moment but seeing well into the future. It could be why I'm making sculpture and working small.

—From a talk with Howard Wooden,
director of the Wichita Museum of Art,
December 1985

BABA AND THE ZEN CALLIGRAPHERS

Chinese and Japanese calligraphers get into a high state of Zen tranquility and perfected consciousness. With quick and masterfully spontaneous brushstrokes they produce remarkable images, free and loose, yet supremely controlled. This takes many years of study and discipline.

I thought of these calligraphers when I painted Baba, an Indian holy man and a friend of mine. I wanted to capture a special expression of kindness, love, and forgiveness on his face—a light that radiated from his eyes, a glow that emanated from him. I found myself exercising, getting into good physical shape before starting to paint. I was like a runner preparing for a marathon. A seven-by-thirteen-foot canvas had been tightly stretched by my assistant, and five coats of gesso were laid out; each coat was wet-sanded until a glass-smooth surface emerged, flawless and perfect, waiting for a picture to be put on it.

When I reflect upon it now, I know I was working on pure instinct, unconsciously, getting myself into shape, creating the right, cleared state of mind to paint. All of the colors to be used were premixed, and brushes, colored pencils, and the airbrush were on call, waiting for the right moment to start the painting.

I then worked for three days straight. I became Baba.

I made no mistakes.

The work seemed to appear on the canvas as if it were *breathed* on.

He glowed.

His eyes shone.

It is now one and a half years later and I have been reluctant to finish the painting, afraid I would ruin it. I seem to be waiting around for inspiration. Perhaps I don't want it to leave the studio. I don't know. It's been up on the wall looking at me for two years. In the interim, I have been working on other paintings. I've never had a relationship like this with a painting before, but I've given in. I've been waiting for the Muse to reappear and it finally has. I shall begin work after the July Fourth weekend.

MORE BABA

The clouds behind Baba are bluer. The inverted sunset (taken from a plane flying into the sunset) at the top of the painting will be further worked upon. The wave is being completed and will probably splash up over the clouds, with shadows behind the exuberant and frothy splashes—free, open, clear, expansive, contemplative, joyous, pain-relieving, refreshing (sounds like an ad for aspirin).

I want the viewer's mind to get absorbed in the reverie of the painting; through the act of looking, the viewer can calm and heal himself or herself.

—From a letter to Thalia Gouma Petersen,
professor of art history, Wooster College,
Wooster, Ohio, August 15, 1983

THE TIME OF BABA

Baba took three years to complete,
 three weeks to paint.
I painted the face in three days.
One and a half years went by.
I thought of the painting every day
 and every night.
Then I painted the roses in one week.
Another year and a half of looking
 and thinking and waiting for the Muse.
Then came the clouds and the blue
 sky—three days.
Finally the ocean—one week.

CONVERSATIONS
WITH ARTISTS:

PERSONAL STORIES
AND PARABLES

LUNCH WITH
ELAINE DE KOONING
AT EDDIE'S LUNCHEONETTE
(EAST HAMPTON)

Some artists work out of anger:
 Van Gogh
 Willem de Kooning
 Michelangelo
 Cézanne (repressed anger)

Some out of joy:
 Frans Hals
 Judith Leyster
 Rubens

Some out of self-indulgence:
 Chagall
 Fragonard
 Miró

Some out of peace:
 Fra Angelico
 Fra Filippo Lippi
 Piero della Francesca

DINNER WITH THE ARTIST
HEDDA STERN
AND THE POET
GRACE SCHULMAN
(EAST HAMPTON)

AUDREY: At night, before bedtime, I try to solve the problem of the painting. Images come to me. New canvases get painted in visionary fashion. By morning much is lost.

HEDDA: I paint paintings in my head at night only during periods of dryness.

AUDREY: I do it all the time.

GRACE: I hear lines, words, images, the muses of the line. I take notes sometimes so I won't forget. Once I dreamed a haiku in exactly seventeen syllables. I wake up with poetry in my head.

AUDREY: I never wake up with a painting in my head. I only go to bed with them.

GRACE: Usually the poems bang me on the head and wake me up.

VISITING THE METROPOLITAN'S SEVENTEENTH-CENTURY FRENCH PAINTING EXHIBITION WITH THE PAINTER HAROLD BRUDER

Poussin composed and painted in such a way that the energy was not released from any part of the painting, especially not from the corners or any of the peripheries. Thus the whole surface, the whole space resonates simultaneously like the taut skin of a drum. As soon as energy is let out from anywhere, the intensity of the painting is diminished.

It is usually easy to focus energy in the center of a painting (like a bowl of fruit in the center of a table) but not overall, the way Poussin does it. Mondrian achieves it, particularly in *Broadway Boogie Woogie*. Cézanne—that clumsy artist—fights to get it, and within his personal struggle lies the fascination of the power we perceive in his work.

MEETING WITH MILT GLASER

Since Milt was going to be the presenter of the St. Gaudens Medal that my alma mater, Cooper Union, was awarding me, we met for lunch beforehand. We resumed our art-school discussions on the nature of art and the difference between fine and commercial art.

During the course of lunch, we found that we knew a man in common, a self-styled guru named Rudy. Milt told me he had been very close to him for many years, when Rudy was the proprietor of a large antique shop in down-town Manhattan. This was at a time when one could still import great works of art from India. Late one afternoon, Rudy was evaluating a new shipment of Buddhas and Shi-vas. He and Milt sat back and viewed the works. Rudy quickly pointed to items and pronounced prices that were anywhere from fifty dollars to fifty thousand dollars. Milt watched aghast and said, "Rudy, you have no background in Eastern art history. You question neither the age nor the provenance of the pieces. How can you price them so quickly with so little information?"

Rudy answered calmly, "I price them by the degree of energy they generate. A great work of art emits more energy than a lesser one."

Milt and I laughed, knowing Rudy was right.

PUBLIC RELATIONS

Years ago, poets and artists used to do what public-relations people do now: glorify kings, praise heroes and beauty, and espouse causes.

> —From a talk with Gene Thornton,
> a photography critic for *The New York Times*,
> at a poetry reading, Guild Hall,
> East Hampton, New York

RAPHAEL SOYER AND ME AT THE CHERRY RESTAURANT

Why have we not been able to produce a Michelangelo, a Leonardo, a Tintoretto? Is it the way artists have been treated recently? We have become unnecessary appendages, expendable. After years of such treatment, perhaps abilities vanish, just as a limb that gets no use gradually atrophies and withers.

This is an age of technology. David painted the coronation of Napoleon. Today we have video equipment to record such events.

WELCOME TO EGAN'S PLACE

Every Saturday, I went to every gallery in New York. It was easy because there were only three: Janis, Kootz, and Egan.

Charlie Egan was a pioneer dealer, exhibiting the abstract expressionist painters long before anyone else had heard of them. He could usually be found sitting alone on a straight-backed hair in the center of his small, one-room gallery, reading *Finnegans Wake*. The quality of light streaming through the windows was beautiful, even serene, as it shone upon him. He had no help, and very few people ever went there. The gallery's manual elevator was so small it could hold only two people, and one of these was a very old black elevator operator, whom I got to know after years of visits. It was comforting to be recognized by him. One did not feel intimidated. The gallery was for the artists. It was one place we belonged. Art was a friend. So were museums.

One day, Egan put down his book, looked up, and asked me to watch the gallery while he went out for lunch. What trust—he barely knew me. It was the first Joseph Cornell show. Those wonderful parrot and astrological boxes filled the gallery. I was thrilled, alone with all those Cornells.

Not one visitor came; they were all mine!

GALAXIES OF LINOLEUM

In a way, the persona of Jackson Pollock was as important as, and perhaps more important than, the art he produced. The archetype he embodied affected all artists, and spread out into the general public in the form of spattered linoleum, lampshades, and clothing. The embodiment of his energy was transmitted through his canvases.

I consider him the first "space artist" in that he took up the mantle of the tilted picture plane from Cézanne and the cubists, and finally raised it to a fully upright position, where he then punctured it. The interlaced sprawling drips flash and flicker like a galaxy of stars. The spaces in between the loops and lacework read as the universe. Art and science always mutually reflect man's knowledge of the world. Pollock, who was attuned to this, took the existential leap, jumped off the cliff, and soared into outer space. He was never to return.

MAKING HISTORY AT
THE CEDAR BAR

When I was a young art student, I frequented the Artists Club and the Cedar Bar. The Club held Friday-night panel discussions and served syrupy black coffee, made by Phillip Pavia, who collected the dues and kept the place running. The site of the club was wherever Pavia found a cheap loft. Both places were hangouts for the abstract expressionists. You could always find a heated intellectual debate, lots of liquor, and incessant art talk. Art! Art! Art! It infused everything, it was a passion!

When Jackson strode into the Cedar Bar, a hush took over the place. Whispers, glances, fingers pointing: "There he is." Everyone knew we were in the presence of someone or something important.

I was seated at a small round table opposite the bar. Jackson was leaning on his elbow at the bar, with his hand holding his forehead. In his other hand he held a drink. The heel of his shoe dug against the rail. He glanced around the room, and his eyes stopped abruptly at my table. He stared at me intensely—strong, piercing eyes, burning inside and out. A straight, uninterrupted beam of vision held the space between his eyes and mine. We had come across each other several times before. I knew that there was something about me he both liked and needed. I had to break the stare and look down; he was overwhelming and frightening, and I was young and not that tough. I was getting scared and high, this time something was happening. I loved his work; here was the man. I wanted to talk art, ask all kinds of questions, find out about him, his work and life. Finally he walked over to my table. He was drunk. A prickly stubble covered his flushed, alcohol-puffed

face. I looked into those sad, sad eyes. I shall never forget them.

It was fashionable to be a drunken artist then. Pollock cut a romantic, swashbuckling figure, pissing in fireplaces of rich collectors, insulting them, acting macho and unafraid—a hero. That was his myth, and I had believed it too, but what I saw here was a desperate man, despairing and terribly unhappy. I felt his pain. I still do.

He saw something wholesome and vulnerable in me. Something bourgeois, young, and not yet spoiled or sordid. Maybe I could help him. He had had enough of art talk, galleries, collectors, and critics. His soul needed mending.

He tried to connect. He hung over me, unsteady and wavering, his face close to mine. We talked and talked, and there was a lot of looking at each other, scanning, examining, and searching. Looking into each other's eyes— looking was more important than talking. It *was* the talking. Then he tried to kiss me, to rub his cheek against mine. Then he belched, and that embarrassed him, so he tried to pinch my behind. He was using machismo as a cover-up for his pain and fear of rejection.

I wanted so much to help him. I felt such a profound connection with him, but to kiss him would have been like kissing a Bowery bum. I could not do it. I was terribly upset with the whole situation, and never returned to the Cedar Bar after that. I realized much later that he must have been in the throes of a total breakdown.

Ruth Kligman was given the job of curating a show for a small gallery on Fifty-sixth Street. She saw my work

on exhibit at the City Center Art Gallery and selected me and two other artists for her show. She was young and pretty, and even though there was something about her that disturbed me, she had a great eye and could talk about art in a way that wove a spell. In her book, *Love Affair*, she describes an early painting of mine far better than I could.

The gallery showed borderline art, and some higher instinct in Ruth recognized my work as the "real thing." She wanted to be close to me. She asked me to give her art lessons. She wanted to know who the other artists were, where they met, and who were the most important of them. I told her. She pleaded with me to take her to the Cedar Bar. I was finished with that part of my life, and refused. I lived on the fifth floor of a walkup apartment building in Chelsea. I drew a map for her showing how to get from West Twenty-first Street to the Cedar Bar, on University Place. On it I wrote the names of Bill de Kooning, Jackson Pollock, and Franz Kline. "Who is the most important?" she asked. "Pollock," I replied.

I walked her down the stairs and pointed her in the right direction. (She was from New Jersey.) That night she met Jackson; the rest is history.

The news of his sudden death sent shock waves throughout the art world. I remember the place and the moment when I first heard the news. East Hampton . . . someone's house . . . a gathering of artists . . . a door bursting open and someone breathlessly yelling, "Jackson just crashed his car on Montauk Highway. He's dead!" We were stunned. At first there was silence, then, "He

can't be dead." Shocked disbelief. A later report said two people were in the car with him; one was dead, one was still alive. Ruth Kligman was with him and was badly injured, but was still alive. A great sense of loss . . . chill . . . grieving.

The same feeling pervaded the country when John F. Kennedy died. These men went beyond their defined roles as artist and President. Jackson Pollock was a magnetic force, both attracting and repelling, holding within his being electrical energy, power, and meaning that reached far beyond his physicality.

Like all great beings do, through some form of osmotic transmission he shared the particles of his structure and his very essence with us. He remains ever present.

BAD WORK

JIMMY: I'm doing bad work . . . there's hope.

AUDREY: I did bad work for a year when I began doing watercolors again after a break of twenty years.

JIMMY: There was a time when it was not held against artists to show bad work. It was expected in terms of their development. There was no sudden death in art then. There is now. Art was a friend. You didn't drop a friend because she or he made a mistake.

—From a talk with Jimmy Ernst
at Bobby Van's, Bridgehampton,
June 8, 1983

EARS LOOKING AT YOU

Esteban Vicente met John Canaday, former art critic for *The New York Times*, at a New York art-world party and asked him, "Do you know the real reason that Van Gogh cut off his ear?"

Canaday said, "No, why?"

"Because he couldn't stand listening to critics anymore."

JOLIE MADAME

Like all still-life painters, I am a passionate collector of props. When I have a particular idea in mind for a painting, it can take a year to search out and gather them.

Jolie Madame started with a concept. I wanted to capture the elusive non-color of glass and the changes that occur in a half-filled bottle, in this case a bottle of Jolie Madame perfume.

I went into my jam-packed prop closet, wandered around the house and studio (which looks like a giant collection of props), and gathered objects for my new painting. I was fascinated with reflective surfaces and textures, so I selected mirrors, jewelry made out of silver and gold, crystal beads, a compact, the velvet-smooth petals of a deep red rose, a porcelain figure, an apple, and a Nippon vase. These were all familiar objects, many of which I personally used and loved, such as a favorite ring and bracelets. I set up a complex and carefully lit still life, and proceeded to paint *Jolie Madame*.

Upon completion, the painting was exhibited in a show called "Women Choose Women" at the Huntington Hartford Museum, now known as the New York Cultural Center. This work, which I thought of as just a still life, albeit of epic proportions, created a sensation. It was both hailed and attacked as a feminist rallying cry. It was called "the ugliest painting of the year" by a *New York Times* critic, and "the ugliest painting of the decade" by an even more pretentious magazine reviewer. I was also referred to as a greedy person, since I included an abundance of objects as well as jewelry. What is the price of a rose?

It took me a while to unravel the true meaning hidden

within the reviews, since greed had no part, and my motive was beauty, not ugliness.

What I realized was that, as a woman, I had instinctively chosen props that a woman would use. My friends, the male photorealists, were also interested in reflective surfaces, but they painted cars, trailers, headlights, and store windows.

By merely being true to my nature as a woman, I had, at that time, broken a silent code. These objects were not to be painted or taken seriously.

Vision is male *and* female. Until recently, the history of art has been the history of male vision. Women dress, look, feel, and see differently. Their vision must be incorporated into the history of art.

CHANEL BREAKS
THE COLLECTION

The reviews of *Jolie Madame* really got to me. I decided that if I was going to be criticized and labeled a feminist, I might as well give the critics cause. I had long been fascinated with the makeup counters in department stores—glass trays, mirrors, colored pencils, disks of wondrous colors in the form of rouge pots, and golden tubes of color in the form of lipsticks. I had also felt that some of the most innovative still-life photography at that time was being presented in the fashion magazines. Some of these photographers influenced me, and I influenced some of them. I painted *Chanel*, one of my most feminist and abstract paintings.

Morton Newman, the famous collector, heard that I was to visit Chicago. He telephoned and invited my husband and me to visit his home and view his collection. I was reluctant and slightly annoyed, because I was not in his collection, even though many of my photorealist colleagues were. Those days were hard for me. I was left out of a lot of shows and collections because of my subject matter. I didn't paint cars, and I was not fashionably dispassionate. I did not fit into that narrow and artificially created definition of photorealism, yet I did not belong with the other realists either. Louis Meisel, the photorealist dealer and writer, was later to augment and create a broader and truer definition of photorealism.

After several tries, Morton Newman persuaded Bob and me to pay him a visit when we were in Chicago. His brownstone was unassuming, even modest-looking, but the inside was astounding! Paintings were everywhere, floor to

ceiling; windows and fireplaces were boarded over and covered with art. Wall-mounted security cameras were constantly rotating and scanning the environment. The first floor housed a vast collection of Mirós and Picassos, and as one ascended the stairs, more recent work was displayed, a wonderful collection of abstract expressionists and finally a full complement of realists—all except me. I mumbled and grumbled to myself, chin down, getting angrier and angrier. Why was it so important for him that I be invited to view but not be part of his collection? Morton's charming wife, Rose, escorted me, pointing out paintings as we climbed to the top floor. Upon our descent, I noticed a swinging door on the third-floor landing. Hanging on it was the smallest Louise Nevelson I had ever seen—ten by ten inches. It was hanging on the door to the kitchen.

Suddenly it dawned upon me. "Is this the only woman in the collection?" I asked. Rose Newman nodded and replied, "Morton doesn't think women can make it—they are not good investments."

By now I was in a silent rage. They both were really sweet people, and I did not want to upset them, since they were trying so hard to be gracious. However, I managed to make my opinion known.

The next day my dealer, Louis Meisel, received a call from Mr. Newman requesting a small Flack. I said to Louis that if he sold him a small Flack it would hang on the other side of the kitchen door, opposite the Nevelson—the women's room. I told Louis never to sell him a small painting; I'd sooner not be part of the collection. To my pleasure

and surprise, Louis agreed completely. He has always seen art beyond gender. He told Mr. Newman that if he was ever to own a Flack, it would have to be a large and major painting, and he would have to pay a record price.

My exhibition was on at that time. Mr. Newman came in the next day and purchased *Chanel*. It broke the collection. After that he bought the work of many other women artists. Ironically, he owns my only intentionally feminist painting, and he loves it.

ROMAN BEAUTIES

Photographing a beautiful still life of Rome Beauty apples and pears, an homage to Meléndez, the Spanish eighteenth-century still-life painter—a lit candle at dusk, cherries. I shot for two days. I just disassembled the set-up, ate one of the pears, put the rest in the refrigerator, put the props back in the cabinet. I thought about doing a watercolor from the original set-up, but decided against it.

There is something relaxing about not worrying about the fruit rotting or the candle burning down, or the light changing. But there is something also that relates to these modern times in that I "recorded" the moment of the still life, a document of that time near the ocean on this planet. That essence of time will be in the painting I make from the photo.

ALONE WITH
MARILYN MONROE

Music has an important place in an artist's life. Most artists listen to music when they paint, and the feel of the music gets into the painting. It is interesting to notice how the styles of music selected change during the course of the artist's development and with the needs of each individual painting.

Earlier, I listened exclusively to chamber music. My favorite pieces were Mozart's G-minor Quintet, Beethoven's Grosse Fugue, and Shubert's Trout Quintet. Later, WBAI, a New York FM radio station, became a lifeline. They broadcast interesting talk shows, political discussions, and an incredible assortment of ancient, Third World, and New Age music. Then popular, folk, bluegrass, and American Indian chants and drumming entered the picture.

I played Elton John's recording of "Candle in the Wind" (a song he wrote for Marilyn Monroe) over and over again while I painted *Marilyn*. I felt the song deeply.

It was in the middle of a cold winter when I moved from New York to my studio in East Hampton for a month to complete *Marilyn*. I was totally alone except for Angela Kaufman, my small but energetic poodle.

Suddenly the sky opened up and we had one of the worst blizzards East Hampton has ever known. Everything froze; the Long Island Expressway was closed due to the hazardous icy conditions. It was hard to get out of the house, and two local gardeners would come by in their four-wheel-drive truck to see if I had enough food and water. The isolation was intense and invigorating. During my painting breaks, Angie and I romped in the snow. She's so small she would get buried, totally submerged, and then rise up

like a dolphin, up and down, up and down.

Music sustained me. The pace of the painting was steady and intense. I listened to a local radio station, WLNG, which broadcast local weather and road conditions. I called in requests to the disc jockey, Rusty Pots, which he then played for me. My human contact was through the radio. When WLNG went off the air, I played Elton John's "Candle in the Wind."

One frosty night, the night of the completion of the painting, I was standing on a scaffold, painting the drape at the top of the canvas. I must have lost all sense of time. The radio went off the air, the record player stopped, and I worked and worked in a state of total absorption. My right arm was stretched upright all that time, gripping a fine brush to control some delicate areas. Finally the last stroke was applied and the work was completed. I stepped down from the scaffold and backed away to gain perspective and look at what I had done. With a sudden sense of shock and fright, I realized that I could not lower my right arm. It was locked into its upright painting position—rigid, frozen.

I had to calm myself. I walked around the studio and gently massaged the muscles of my arm until it slowly lowered itself.

My arm recovered by itself, and Elton's song is in the memory bank of the painting.

JOHNNY CARSON

Sometimes when I am alone in the studio, I think about Johnny Carson, walking through the curtains of a Hollywood proscenium arch and receiving applause and adulation.

Artists are alone, by choice.

When I placed the very last brushstroke on my painting *Marilyn* after a two-year involvement with the painting, no one applauded. I stepped down from the scaffold. It was 3:00 A.M. Snow covered every inch of earth and sand. The snow-silence was white and loud. It comforted me. It seemed to envelop me. It became my friend.

When artists are alone at those times, we receive other rewards.

THE FALLACY OF INTENT

Looking at Jim Starett's work . . . lots of swastikas and images of the Pope upside down. Pat Steir knows him and says he was a draft resister and was imprisoned for two years. I question the swastika imagery—can they be interpreted as positive? Peter Morrin says, "You dealt with that imagery, Audrey, in your *World War II* painting." I remembered the mixed reactions and sometimes violent misinterpretations by some critics. In the discussion that ensued, I said that my intent was clear, and yet it was partially unclear for the public. Peter stated that it was important for the intent of the artist *not* to be absolutely clear. If the intent is clear, the work becomes only propaganda. Ambiguity is important. If the work reveals only the artist's intention, it is less than what it could be. The work becomes important when the meanings contained are greater than what the artist had in mind when he or she created the work. Ambiguity helps the work transcend itself.

—From a talk with Peter Morrin,
curator of contemporary art,
High Art Museum, Atlanta, Georgia,
and Pat Steir, artist,
while jurying for the NEA awards.

VERMEER AND
THE *MONA LISA*

I had lunch at the Metropolitan Museum with Bill Lieberman, the Metropolitan's chairman of twentieth-century art, and Paul Gottlieb, president of the Abrams Publishing Company. It was a memorable event for two reasons. One was an unforgettable coconut layer cake with succulent icing, flecks of shredded coconut adhering to it. The other was that Bill Lieberman took me to see a recently acquired Vermeer. The museum had made no fanfare about it, so it had gone basically unnoticed except by those who knew and cared. It was a small painting entitled *Portrait of a Young Woman*. It had been sold at auction in Amsterdam on May 16, 1769, and had been described in the auction catalog as "a face in antique costume, uncommonly artistic, thirty-six florins."

Thore Burger, the French nineteenth-century critic, compared the grace of the sitter in this painting to Leonardo's *Mona Lisa*. But the brilliant and astute eye of Bill Lieberman had detected something other than perfection in this marvelous work. He pointed out something askew in the presentation of the model's left arm. There was also something odd about the head that suggested that something may have been wrong with the sitter.

I looked at the painting more closely and studied the model's left arm. Bill was absolutely correct. There was a distortion somewhere around the wrist or lower arm, something that could almost have been a deformity. That area of the painting was terribly unclear. It was hard to determine exactly what was wrong or exactly where it was located. I believe Vermeer retained the defect in order to maintain

the veracity of the painting, to capture the truth, but I also believe he painted the area in a specifically unclear manner to reduce the impact of the imperfection of the sitter. Upon further examination, I noticed that the forehead and chin were exaggerated and bony, almost hydrocephalic.

I am convinced that the sitter was not a perfect and beautiful woman like the Mona Lisa, but one who was physically damaged. My feelings tell me that the young woman in this painting may have been one of Vermeer's many children. References to them are sketchy as to their health and survival. If this is so, it could account for the beauty we see radiating from the painting. We could be in the presence of the love of a father for his daughter. Her soulful eyes and gentle smile reflect to us the tenderness and love Vermeer felt for her.

Compare this with the Rubens portrait of Clara Serena, the child of Rubens and Isabella Brant. Here a father also paints his daughter with tender intimacy, but she is clearly a healthy, beautiful, perfect, and vibrant child, outgoing and energetic. One senses her future sexuality.

The Vermeer portrait exhibits a quietude and reticence, and exudes a gentle protective atmosphere. Vermeer has transcended society's standards of perfection and superficial beauty. Through his love he has shown us the true glow of beauty from within, and has even made us believe the beauty of this young woman.

BURN OUT

I had a premonition that I would die after I completed *World War II*, the third and last of my *Vanitas* paintings; and, indeed, I became seriously ill later that year. No one ever discovered what was wrong with me, although there were numerous guesses; high sedimentation rates indicated that my body was fighting something off.

On top of it all, I developed a bad case of mononucleosis; this made sense, since my immune system was weakened. The life force was draining out of me.

I was so weak I could barely walk, and stayed in bed for one year while blood tests were done continuously. I experienced a depression unlike any I had ever known. It was a physically caused depression, quite different from my usual ups and downs.

The siege lasted for three years, but the final year turned a corner and I started the process of healing.

Baba recommended that I go to a place called the Himalayan Institute in Pennsylvania, started and directed by his old friend, Swami Rama.

"What is a Swami Rama?" I asked skeptically. But faced with prospects of a quick entry into a New York hospital as a last desperate measure, I chose the Institute instead. They had a ten-day "Combined Therapy Program," where I was seen by a homeopathic doctor every day. I was to talk to no one but the doctor, and then only when I had an appointment. Meals were brought to my room, which was clean, small, and bare. I was to eat alone and concentrate on the food when eating; sleep when sleepy; be by myself the rest of the time.

Up at 6:00 A.M.; lemon drink and yoga from seven to

eight; walk; breakfast at eight-fifteen. Lectures on nutrition; the connection between mind and the body. *Pranayama,* the science of breath; a course in meditation. Biofeedback and the *Bhagavad-Gita.*

I came away from the Institute with an understanding that has changed my life. Within that time, and the years that followed, I learned how to heal myself, and to help others do the same when they were open to it.

Body, mind, and spirit are one. The mind has the power to make the body sick; it can also heal it. To a large extent, we control our own destiny. It is no accident when we become ill.

I was burnt out, and disillusioned with the art world.

TIME OUT

After not seeing each other for several years, Cindy Nemser and I met for lunch. We talked about the importance of taking time out, which we had both done. I asked her to jot down and send me what had come out of our chat.

Art can be: joyous, exciting, life-enhancing, fun-packed, insight-provoking, exalting.
Art can be: terrifying, frenetic, devastating, deadening, life-draining, mean-spirited, illusion-shattering.

When art is mostly all of the first category, it means the go-ahead signal is on. When art is mainly all of the second category, it's time to go dancing.

PAINTING ANWAR SADAT

It was during the Camp David talks. Begin, Sadat, and President Carter were meeting to attempt to bring about peace in the Middle East. The PLO was on the attack: a dangerous time. I was watching the 11:00 P.M. news on TV. I listened to Sadat, looking carefully at his face, adjusting the color on the set. I said to Bob, "I believe that man wants peace, he is putting his life on the line. I would like to paint his portrait. Certainly if he brings peace to the Middle East I will paint him."

The next morning at 11:00 A.M. an extraordinary or extrasensory event occurred. Out of the blue, with no previous contact, I received a call from *Time* magazine asking if I would consider painting Sadat for their cover. He had just been selected Man of the Year. Since the selection takes place one week before the magazine goes to press, I had to work fast. Walter Bernard, the art director at that time, supplied slides and photos. I would have liked to work directly from Sadat as well as from the photos, but he was in Egypt, and even *he* didn't know about his selection. The secret of who was to be Man of the Year was well guarded.

I became intensely involved with Sadat's visage—his black, wiry hair and his dark, full, Egyptian eyes. I was intrigued with the way light glistened on the oily surface of his skin, emphasizing his pores. Laying the ground color for his skin, a reddish sienna, I thought, my God, he is an Egyptian. His skin was pulled taut over his skull and cheekbones. Mummy images flashed through my mind. His heritage was clear, intense. I liked his face.

When the portrait was published, Sadat's head overlapped the broad red *Time* border. I had included a rainbow

arc in the background, to evoke a feeling of peace. I used the colors of the Egyptian and Israeli flags in the rainbow.

When Sadat saw the cover, he called *Time* from Cairo and said he wanted to own the painting. The arrangement that *Time* made with me was that I was to be paid for their use of the painting, but since it was a painting and not an illustration, I would retain the actual artwork, giving them reproduction rights. My intent was to present the painting to Sadat, if and when there was a peace agreement.

I was away lecturing, and when I called home I was told I had received several frantic phone calls from *Time*. They now wanted to purchase the painting. I was told nothing of the Sadat request. "Fine," I said, "but if you have any idea of giving it to him, I want to be there. That is my one wish." Unfortunately, I put nothing in writing. They bought the painting. I kept reminding them of my desire to present the work to Sadat along with them if necessary.

A month later, there appeared on the editorial page of *Time* a photograph showing the editor at that time handing Anwar Sadat my painting. It had been framed, and a gold plaque was affixed to it indicating that it was a gift of *Time* magazine to its Man of the Year. They were standing before an audience that *Time* had invited to tour the Middle East. I was not there, nor was I ever told about it.

Months later I received a letter from Sadat thanking me for the painting, praising it and telling me how much it meant to him. I'm glad I was able to give him something; we connected, and it meant a lot to me.

I was horrified at his assassination. He really did put his life on the line. I wonder where the painting is now.

CÉZANNE OPENING
AT MOMA

The Museum of Modern Art in New York held a special preview for artists only, to view Cézanne's late watercolors and oils. It was a wonderful idea, much appreciated by the artists, or at least by me.

Artists look at paintings differently. They like to get up close, to touch and feel. (Even though they're not supposed to, they consider it their right.)

They discuss the quality of light and the handling of space and color:

"Did he use vermillion or cadmium orange?"

"Look at those brushstrokes."

"See how he had the guts to leave the area seemingly unfinished."

There were clusters of artists hovering around individual paintings, and there was lots of art talk. The evening was animated, yet there was a sense of respect for individual artists who wanted to be alone with a painting.

Artists were present who hadn't spoken to each other in years. Various factions waited for other factions to move away from a painting so they wouldn't collide.

Nonetheless, we were all one family, relatives, connected with Cézanne, the godfather. He held us together, kept the factions at bay. Like relatives, we fight. Cézanne reunited us, if only for an evening.

LUNCH WITH
BILL DE KOONING

Winter in East Hampton can become lonely. The cold, violent ocean, white sky, and barren trees create a stark landscape. Damp, raw air chills your bones, and fog rolls in and slowly envelopes everything. The conditions are good for working. Artists visit each other for warmth and companionship.

I went to Bill de Kooning's for lunch today. Tom, his assistant, made delicious vegetable omelettes and I brought (at Tom's request) a decadent-looking double-chocolate mousse cake, shaped like a bowler hat, as well as my book *Audrey Flack on Painting*.

Bill was very admiring of the starkly realistic technique and asked me many questions, particularly about acrylic paint, which he was interested in trying. He remembered his days at the Academy and proudly showed me a still-life painting from that time.

There were many canvases stacked around his cavernous, glass-enclosed studio. I felt they were there for his own personal referral and contact. Old paintings are company. Seeing Bill again brought back memories of my days at the Cedar Bar, the Artists Club, and the now-defunct Sagamore Cafeteria. I had cut my teeth on abstract expressionism. Bill de Kooning, Jackson Pollock, and Franz Kline were my heroes. I studied their work intensely, memorizing individual paintings. De Kooning's *Attic* and *Excavation* greatly influenced my vision.

I refocused and asked Bill if he thought one of the new works was finished. It looked thin and incomplete to me. The canvas was painted white, on top of which were two

red and blue, curved vertical stripes, looking as if they were applied in one long stroke with a four-inch-wide brush. There were a few other marks, but not much more. He responded, "Well, I could work on it more, it could use more work, but I think I'll leave it and do another."

A painting can be finished at many stages, and sometimes it is good to let a work complete itself at an early stage of its development. Abandon, freedom, and looseness are necessary at times, but not at the expense of a too-thin or incomplete painting.

When every mark an artist makes is considered significant and is sent into the marketplace, it must have an effect on the psyche and nature of the work the artist produces. I don't believe de Kooning's primary concern was ever money. Something else had happened to him through the years, something having to do with both maturation and aging—aging of the eyes, the body, and the mind— patience and impatience, a sense of self, and of being a public figure of such renown. He was subjected to the bombardment of words, both praise and criticism, of demand for work, and of his paintings becoming an international commodity.

In the life of an artist, one can become too tight or too loose. When the pendulum swings to extremes, it wants to find its natural center.

Many abstract expressionists went too far out and never came back, committing one form of suicide or another. They had painted themselves outside of their own lives and had lost their ability to return to their center.

ON RETROSPECTIVE
EXHIBITIONS

Retrospectives are about the stretch of the journey of the artist. Some artists should have them, others not.

Some artists travel great distances. Their work unfolds like a book developing in time—Manet, Pollock, Gorky, Cézanne, Kandinsky, Matta.

Other artists (most American abstract expressionists) intensify during their lifetimes—Rothko, Still, Newman, Reinhardt. It seems as if they paint the same picture their entire lives, but it just gets more and more intense.

There are artists who do both, like Rembrandt and Van Gogh, and those are the miracles.

—From a talk with Tom Messer,
director of the Guggenheim Museum

SKETCHING THE LAOCOÖN

It happens everywhere. In China, sketching a pagoda; in Rome, sketching the statues at the Vatican. Right now I am standing before the Laocoön. I have a small sketchbook and a box of terra-cotta Prismacolor pencils. Watercolors need an entirely different set-up: a palette, a chair to sit on, a water jug, brushes, a sponge or rag, a watercolor block, and a set period of time. All I want to do is make quick two-minute studies. I stand cradling the book in my left hand, drawing with my right. I try to be unobtrusive, but somehow the onlookers find me. They respond with nods and comments, criticism and compliments.

People feel they have the right to watch artists work. The artist becomes public domain. I feel self-conscious . . . eyes peering over my shoulder . . . people standing too close, elbowing and jostling to get a better look. The verdict from these noisy Italians is that they like my drawing; they express admiration. I smile and nod, acknowledging their remarks. My drawing has expressed their feelings for them. In that sense, I have become a public figure.

Rome, May 1984

THE VIBRATIONS
OF VENICE

Art is the concretization of the energy, hopes, and aspirations of humankind. Every era generates its own energy.

We all have within us the ability to know everything that has ever happened.

In Venice, the energy system is so high it is unquestionable. The architecture, painting, sculpture, and mosaics solidify this energy and give it the three-dimensional form of the era in which the works were made: the Piazza San Marco, the Doges' Palace, the clock tower, Santa Maria della Salute, Tintoretto's Scuola di San Rocco. The thousands of stonecarvers, mosaicists, and builders worked together to form a miraculous superhuman preternatural landscape that emits light vibrations. Love comes pouring forth, and everyone understands it.

Venice is a city of total fantasy brought up to a concrete, touchable level, and like a star, with finite "light" years of life, its time is fading. Venice is sinking while the waters are rising. The statues are losing particles of their stone to the atmosphere.

The artists and builders of Venice have done their job. Their gift to the world is completing itself.

THE BEAUBOURG

A perfect example of irreverent architecture. Masses of Euro-youth descending on the Pompidou Plaza and then the museum. The feeling is like that of entering a sports arena.

The exposed pipes and columns of the building excite the eye—lines everywhere, vertical, diagonal, horizontal; tubular, glass-encased escalators and pathways—everything and everyone moving. The building vibrates and trembles.

In this environment it is difficult for the mind to become still. How can the viewer come into contact with that special place within the self that art triggers?

The plastic tubular encasements are beginning to leak. The high-tech rubber floor pads are buckling; paint is peeling; sealers are flopping off the window enclosures. This child of a building is aging too fast. It is rapidly reaching its own short-lived destiny.

TINTORETTO
AND THE
SCUOLA DI SAN ROCCO

Tintoretto died on May 31, 1594.

I visited his paintings on May 31, 1984.

Three hundred ninety years later, a day after my birth-
day, May 30, 1984. The church bells were ringing vigor-
ously, announcing noon. Light was streaming onto the
panoramic *Crucifixion* painting. I was in contact with a
higher force, feelings beyond myself. This magnificent and
enormous painting takes up a whole wall.

The crucified Christ looks down upon the group of
mourners at the foot of the cross. He looms over the entire
panorama spread out before him. Light rays emanate from
behind his head and outstretched arms, giving the illusion
of a giant bird beating its luminous wings—*the dove and the
Christ have merged. We are watching the moment of transition.*

Tintoretto is in full command of his chiaroscuro, di-
recting the viewer's eye around the painting with flutterings
of dramatic darks and lights. Energetic activity abounds.
The two thieves flanking Christ are being raised onto their
crosses. Horses, workmen, worshipers, tormentors are all
engaged in baroque action.

The interaction of the figures, the complex composi-
tion, the color tonalities, the darks and lights create an
incredible excitement as well as a harmony that raises the
painting to a supernatural level.

It was not déjà vu, but the very same enactment that
had taken place in 1956, when I first visited Venice.

Twelve noon, bells ringing, sunlight streaming right

onto the central Christ figure. At that time I experienced feelings of incomprehensible ecstasy.

Now I had other feelings. I was coming from a quiet place, being a part of it and witnessing at the same time. I leaned back against a wall, breathed deeply, and felt very still.

TINTORETTO AND
VAN GOGH

One feels that Tintoretto was directed by a force outside of himself. The superhuman energy system vibrating off the walls and ceilings of the Scuola di San Rocco leaves no question of this in my mind. Tintoretto devoted eighteen years of his life to the Scuola alone.

Van Gogh also had to have been directed by a force outside himself, when one considers that his entire body of mature work was produced in four years. It doesn't seem humanly possible.

Yet within the frenzy and fits and starts of his tragic and passionate life, he learned everything he needed to know to manifest his spirit visibly in those four years, from his arrival in Arles until his death. A condensation of art-school education, mind, career, and masterful painting into an astonishingly short time. A flashing comet, *A Starry Night*, emblazing the art world, leaving its illumination, and then gone. . . .

CLAUDEL AND RODIN

We arrived in Paris on May 15. This was a time for art—looking, visiting museums, and sketching. I saw a poster announcing an exhibition of Camille Claudel at the Musée Rodin.

I had never felt drawn to visit the Rodin Museum in Philadelphia, though I passed it frequently. Rodin is an artist I kept at a certain distance, although I never knew why, and I always felt slightly guilty about it.

Here at last was an opportunity I would take to pay tribute to, and finally deal with, Rodin. And I have come more and more to believe that everything happens for a reason.

I had never heard of Camille Claudel, and had even forgotten about the exhibition announcement. So, upon entering a hall of the Musée Rodin, I was surprised to come upon some sculpture that was new to me, superficially Rodin-like, yet possessing a totally different energy. I began to respond empathetically; I liked the work. I became excited by the forms, the images, the weight and balance of the figures against each other. The limbs were a bit thin, I thought, almost spindly in comparison to Rodin. The proportions and dimensional sensibility reminded me a bit of my own sculpture. I felt reassured. I had always felt Rodin to be a bit heavyhanded—too thick, massive, forcing issues too aggressively. This exhibit confirmed my feelings. I had discovered a new artist! Why wasn't he known? I liked him better than Rodin. We bought a catalog as we left the gallery, and my husband said to me, "From what I see in the catalog, Camille Claudel appears to be a woman."

Indeed she was. The name Camille had reminded me

of Camille Pissarro, but this was a feminine Camille, a woman about whom many French artists say, "Claudel was Rodin." She worked in Rodin's *atelier*, was his lover, and sculpted many of his pieces. The hands and feet of *The Burghers of Calais* were Claudel's, and they were the parts I most liked in that work. Her energy was strong, unnerving. She was later to go mad (so they say) and was institutionalized for thirty years.

I am sure I picked up her energy from the poster I saw announcing the exhibition.

Another woman artist is discovered. . . .

BOILLY AND MONET

Another poster that sent its message to me was one that announced an exhibition of Boilly. Who was Boilly? An obscure French artist whom I had vaguely heard of. He was not considered very important, yet I knew I must see the show. We went.

Boilly was a marvelous painter, a delight to see. I sensed a devotion to art like that of Vermeer or Chardin, a lover of paint and form, a bourgeois man and a teller of stories.

Some of his illustrative works made me laugh out loud.

A refreshing surprise—a totally honest and beautiful artist! Hidden away and finally, gently exposed at the Marmottan Museum.

Downstairs, on permanent display, were seventy-three Monets. After taking one and a half hours with Boilly, my eyes scanned the Monets in ten minutes. There were several of what I called "cataract paintings." Done in brown and red, they upset me because I knew Monet suffered from cataracts when he painted them, which caused the color distortion. There were a lot of mediocre paintings and a couple of good ones, but none held for long. What a disappointment; Monet is a great master whose works I admire, yet even a master's output must be evaluated properly.

—Paris, May 18, 1984

THE FOUR HORSES
AT XIAN

Traveling through China, two weeks into our trip—coughing—polluted air everywhere, heavy industry with no environmental controls. We have not seen the sun since we arrived. Absolutely no color. Everything is dusty—yellow-gray, clay, terra-cotta. I'm feeling depressed and am coming down with a Chinese respiratory ailment.

We arrive at Xian, site of the excavation of Emperor Qin Shi Huang's tomb. An overwhelming sight: six thousand life-sized terra-cotta warriors—an entire army before me.

And then it happened, the pulse-pounding experience that occurs when one comes into contact with a masterpiece of superhuman energy, a transcendent work of art.

Here were four bronze horses, plumed and harnessed, pulling a small chariot with a rider inside. They were less than life-size, so it wasn't the scale that got to me.

Beyond the incredible beauty of proportion, technique, and craftsmanship, these horses were compellingly alive.

They were neighing—speaking to me—proud, joyous, prancing, an "up" feeling. Above all, in this severely controlled and repressed country, here was truth unbridled, coming from these horses, from an ancient artist's energy.

Tears flowed from my eyes. It was similar to experiences I had with the *Macarena Esperanza* in Seville, and with a Botticelli Madonna at the Morgan Library. Time stood still; art once again cut through unreality and presented bare energy, truth, and joy.

RAPHAEL

We visited an exhibition of the drawings of Raphael at the Gallerie dell'Accademia di Venezia, on May 30, my birthday—what a present!

Raphael drew on both sides of the page, with an exquisite precision of line.

The works were mounted in such a way as to expose both drawings. You could see the opposite image bleed through. What a lack of ego, I thought, to draw on both sides of a page; or, rather, what high standards. These "magnificats" were considered by Raphael to be only studies—sketches, remarks for future works.

Another more noble and egoless attribute I observed was that Raphael copied extensively. There, before my eyes, were tracings of Mantegna, copies of Leonardo, Carpaccio, and Perugino. That is the way to learn—from your masters!

CÉZANNE'S IMPRINT

Great artists put their imprint on nature and life. When I visited Aix-en-Provence, I climbed the hill to Cézanne's studio to pay homage to this master of mine. After resting my eyes on every object in his studio and feeling his presence, I went outside to do a watercolor. The entire landscape looked like a giant Cézanne painting: Mont Sainte-Victoire, the terra-cotta tiled roofs, viridian green foliage, and blue sky. His paintings made the landscape more real.

To this day, thirty years later, Cézanne's painted images are stronger in my mind's eye than are the actual ones.

MYTHS AND
THE SPIRIT

HOLDING THE SPIRIT

A work of art is the energy manifestation of the one who created it. It holds the spirit of the artist within its shapes, forms, and colors.

The Mohawk Indians have a saying: "We believe that all living things are spiritual beings. Spirits can be expressed as energy forms manifested in matter. . . . A blade of grass is an energy form manifested in matter . . . grass matter. The spirit of the grass is that unseen force which produces the species of grass, and it is manifest to us in the form of real grass."

AN ART OF BALANCE

The healing qualities of art are not just the concerns of twentieth-century "new age" fanatics, but have always been part of the concerns of the masters. Henri Matisse said: "What I dream of is an art of balance, or purity and serenity, devoid of troubling or depressing subject matter, an art which could be for every mental worker, for the business-man as well as the man of letters. For example, a soothing, calming influence on the mind, something like a good arm-chair which provides relaxation from physical fatigue."

DIS-EASE

Great art is in balance, in harmony. Disease is dis-ease. Out of balance, out of harmony. Art that is in balance and harmonious is restorative, soothing, and healing. Chaotic, disruptive art without any inherent order or balance can be damaging.

The act of producing disturbing art can be temporarily therapeutic for the artist in getting rid of anxiety and expelling bad feelings. The effect of such images on the viewer is another matter.

DISAPPEARING ART

Just because artists make work that will fall apart or blow up, with no regard for permanence, does not mean that they are not materially involved and are therefore not true artists.

Shamanic Indian sand paintings disappear within days or even hours after having performed their purpose in the healing ritual. Most often they are done with great care and precision. Their disappearance has to do with accomplishment and healing, not with fashionable disintegration.

THE EFFECT OF COLOR
ON SICKNESS

"The effect in sickness of beautiful objects and especially of brilliancy of color is hardly appreciated at all. . . . People say the effect is only on the mind. It is no such thing. The effect is on the body too. As little as we know about the way in which we are affected by form, by color and light, we do know this, that they have an actual physical effect.

Variety of form and brilliance of color in the objects presented to the patients are an actual means of recovery."

—Florence Nightingale (1860)

COLORS OF THE SPECTRUM

Colors of the spectrum vibrate at different levels. Colors on a canvas send out vibrational energy on an infinite number of levels.

When we observe a painting, the light and energy systems of our bodies and minds meet the energy system of the painting. When we come upon a masterpiece such as the *Alba Madonna*, for instance, the harmonic vibrations emitted merge with the higher energies of the self, and we actually feel a sense of peace or exhilaration, of harmony or excitement. At this level, art can heal.

WORLD WAR II

It is now eight years later and I am beginning to understand what happened with my painting *World War II*. It had been my intention to both shock and seduce the viewer at the same time. I wanted to shock because the nature of the subject matter went to the edge of human depravity—the extreme limits of good and evil.

Yet, I did not want to show any mutilation, feeling as I do that the world has more violent images than it can handle. I had to find another way.

I shocked the viewer by contrasting starving, ashen-gray prisoners with the ultimate in excessively indulgent food—creamed petit fours. But this was not the major thrust of the shock. It was to come from the juxtaposition of colors and shapes, densities and hues, which set up a tense vibrational system.

I seduced the viewer at the same time by the perfection of color mixtures, forms, sensuous surfaces, sizes and spatial relationships, and succulent mouth-watering sweets.

I think, now, it was not only the subject matter, but the vibrational level of the entire painting that affected the viewer. I had set up both jarring and discordant vibrations, as well as peaceful and transcendent ones. I wanted to create a stasis and a dynamic symmetry.

The painting's border was extremely important to me. Each color was carefully selected in terms of exact width, density, and hue. The entire border was meant to frame the painting, act as a mourning band, calm the viewer, seal the limits of the painting, and lead to outer harmonic dimensions.

Many viewers handled the painting well. A few reviewers had trouble—recoiled and attacked. I wonder what their reaction would be now that so many years have gone by.

ANTI-NUKE RALLY

At the Stephen Wise Free Synagogue there were many moving, sincere speakers—Jesuits, rabbis, a group of survivors from Hiroshima. Into this scene, amid the humming and clicking of news cameras and tape recorders, two American Indian chiefs walked slowly and proudly to the podium. Everything stopped. They permitted no photos, no recording of the event, no TV, no documentation. They said a quiet and beautiful prayer for our Mother Earth.

They sang and did a small dance. The purity was absolute. It was not tainted by the ego becoming involved in its recording. It was a true prayer, and it went out into the universe.

TRANSCENDING
THE HORROR

Saying the phrase "I don't want war" is entirely different from saying "I want peace." Using the word *war* conjures up a warlike image in the mind, as well as feelings of anger and anxiety. When one uses the word *peace*, the mind grows calm and the body quiet.

This works the same way for visual images. The image of a soldier torturing a prisoner, or of a woman being raped, can cause further abuse unless they transcend and reach a higher order of harmony, even though they may retain disturbing elements. One reason Picasso's *Guernica* succeeds is that it has been abstracted. A starkly realistic, brutal image is far more difficult to transcend.

I consider Grünewald's masterwork, the *Isenheim Altarpiece*, to be one of the greatest transcendent images in the world today. Christ, hanging heavily from the cross, is gangrenous and pockmarked. His flesh has turned green and a deathlike pallor has taken over his body. The crown of thorns has pierced the skin of his forehead, which drips blood. His hands and feet are gnarled, twisted, and knotted. His rib cage has collapsed under his own weight, and blood pours out of the gash in his side.

Grünewald has pushed his image to its outer limits, and through his magnificent artistry and spirit, using color, composition, technique, and iconography as his tools, he has managed to transcend the horror of the initial image.

THE CURRENT BANDWAGON

The current bandwagon image is "the end of the world"—giant group shows depicting the nuclear holocaust, then a party afterward to raise funds for the museum and to publicize the artists.

This is not to say that artists are not truly concerned. Artists, of all people, should express their concern—but it is important for them to steer clear of fashion and hype, particularly in today's society.

THE PASSING PARADE

"When you can see the bandwagon, it's already gone."

—Willem de Kooning

THE POWER OF THE ICON

For centuries, art has been destroyed by conquering armies. Violent emotions are evoked in the public through art. George Segal's public sculpture smashed; Michelangelo's *Pietà* bludgeoned with a hammer; Robert Irwin's work splashed with red paint.

What is it within the art that sets off these powerful feelings?

A pin piercing the eyes in a photograph of someone you love would make you wince, even though you know it's just a photograph. The power of the iconic image rises above the limits of intellect and reason.

THOUGHTS
CIRCULATE AROUND
THE UNIVERSE

Goi Sensei taught that everything in this world is made up of vibrations. Even the thoughts put out by each individual become vibrations to circulate around the universe. If one puts forth a negative thought, this means that a negative force has been added to the mind of the world. The thoughts of each individual influence the destiny of mankind; in fact, they gather to form its destiny.

Visual images have enormous power. Artists send their images out into the world, sometimes without realizing their impact. Putting forth harmonious vibrations through art is essential for the well-being of society.

THE SURVIVAL OF
THE ART WORLD
VS.
THE SURVIVAL OF ART

If art is not for people, who is it for?

ART TRUTH

Art truth is simple. It is certain critics who insist on making it complicated. Art can be understood by everyone. One does not need intellect to understand the source. Art history and aesthetics are another matter. Writers about art can help to illuminate and clarify the truth.

WHEN VISION APPEARS

Certain kinds of genius emerge early, like mathematicians and musicians who, through some form of genetic lineage, carry within them the seeds of highly computed information. They can start at five years of age and complete at twenty. But for the most part, vision appears to each of us according to the linear span of our lives. Some peak early, some late, some at a steady, even pace. We seem to have no choice as to when it happens.

Each artist develops differently. There is the phenomenon of Van Gogh, who starts to paint late in life and achieves miraculous results in four years. Masaccio changes the history of art by the time he reaches twenty-seven years of age, then dies. Titian, Tintoretto, and Michelangelo lived long lives. Their talents bloomed during their entire lifetimes.

DYING ON TIME

If a man dies before he dies, he doesn't die when he dies.

Through their work, artists can revive their lives to die on time.

TIME-RELEASE ART

There is a given amount of time we are to live on earth—a given amount of food we are to consume.

You can't make any more works of art in your lifetime than you are supposed to, nor can you get to where you're supposed to go before you are ready to be there.

By becoming aware of his or her own inner art storehouse, the artist can ease into a life of art, trusting the inner time-release process.

By letting go of desperation and fear, artists can produce at a steady pace, gradually, using their stock of creativity, generating only what is needed.

TIME AND THE RITUAL ACT OF ART

From Picasso, a pivotal figure, to the present, the art world has been burdened with the seeming irreversibility of profane linear time. New "in" galleries, dealers, and artists appear every year, only to be replaced by another fashionable group the next year. The very essence of great art is its ability to cut through time.

In *The Myth of the Eternal Return*, Mircea Eliade states that primitive man believed that an object or act became real only insofar as it imitated or repeated another's ritual act. Inherent in the imitation of archetypes and in the repetition of paradigmatic gestures is that, in this way, time was abolished.

A current sacrifice, for example, not only reproduces the initial sacrifice at the beginning of time, but it also takes place at the same primordial, mythical moment; every sacrifice repeats the original sacrifice, and coincides with it. All sacrifices are performed at the same mythical instant of the beginning. Through the paradox of rite, profane time and duration are suspended.

What we discover in probing archaic rites and rituals is the willingness to devalue time.

Carried to their extreme, all the rites and all the behavior patterns would be contained in the statement "If we pay no attention to it, time does not exist."

Contemporary man has worshiped time and become a slave to it by establishing a cult of originality, a cult of the new, denying past influences and tearing down historic architecture. If time consists of the past, present, and future, and the art we create is only the new, with no inclusion of the past, then it too shall not have a past or a future.

DÉJÀ VU

Déjà vu could be a circular-dimensional or holographic sense of time. It could be a reliving of the ritual act.

REMBRANDT AND THE RITUAL ACT

A Rembrandt self-portrait is as alive today as the day it was created. Each time we look at it, we reenact the ritual of calling it to life, the very act of which has taken place by others performing this ritual for several hundred years.

Profane time and duration are suspended. The image of the painting glides through time and space, in another dimension.

REMBRANDT

What about a painting really lasts longest? Would it have been enough if Rembrandt himself had come into contact with people without ever having painted a painting?

Does everyone who has seen and been moved by a Rembrandt carry that force and disseminate it for future generations who may never see the work?

—From a talk with Nai Chang,
graphic artist and designer,
December 30, 1982

THE REMBRANDT
OR THE LIFE

When I was a passionate young art student, I posed a problem for myself. I visualized myself on an ocean liner that began to sink in mid-ocean. Everyone had drowned but me (who could swim), one other person (who could not swim), and a priceless Rembrandt. Which would I save, the person or the Rembrandt?

Well, the Rembrandt was an irreplaceable masterpiece. It would be lost to society forever. Then I thought, What if the person was an old man who did not have long to live anyway? Which would I save?

I mused upon this question for some thirty years, rephrasing it, changing my mind, and always trying to justify saving the masterpiece.

I can tell you now, unconditionally, I would save the life.

TIME SPENT

Grünewald spent years of his life on the *Isenheim Altarpiece*. Matisse's art appears to materialize in a moment. Only the appropriation and major shifts in the usage of time are different.

The length of time it takes to make a work does not necessarily make it good.

Conversely, the spontaneous and rapid production of a work does not make it good.

Supremacy in art lies outside the realm of countable time.

JACKSON POLLOCK, THE LOST SHAMAN

A shaman is someone who has been through the fire, who has been ill and healed himself. The shaman can then return and heal others. Jackson Pollock was a lost shaman.

He committed a public suicide. But it wasn't art that killed him.

Had Pollock retained a joy for painting, it could have saved him. Because of his inner personal turmoil, combined with the tearing and wrenching of the "art world," it became more and more difficult for him to paint. He would wait for the very last moment to complete a show, staying up all night drinking, abusing himself. Art could have saved him. He lost his way.

MYTHS AND THE ARTIST

Myths are presentations from the collective unconscious of psychological and spiritual truths. For Jung, myths have meaning for everyone because they represent "archetypes"—that is, patterns of life that are universally valid.

Artists revive old myths and generate new ones. Because their primary sources are spiritual, nonmaterial, they can have clearer vision. By the use of myths, artists put society in touch with universal basic questions and feelings we all have about life.

MONDRIAN

Great art has a life force. It is transmitted from artists, through their hands and brushes, onto the canvas. This force transcends technique, style, medium. Without it, the art may be good and even professional, but not great. It is what makes Mondrian magical. One could easily copy a Mondrian, but his special touch—those short, staccato brushstrokes and the thickening of the paint at the linear edge—energizes the entire painting and creates the magic.

ART AND SOCIETY

NOTHING EVER CHANGES

"A new art! But what for? Art is eternal, it is unique. Our art is the same as the art of all other times. We do the best we can and when we do as well as our masters, that's all we can hope for."

—William A. Bougereau (1825–1905),
 1891, at Wadsworth Atheneum,
 Hartford, Connecticut,
 as quoted in catalogue and part of exhibit
 of October 1984 to January 1985

THE AVANT AVANT-GARDE

We have become conditioned to thinking of the avant-garde as noisily disruptive, violent, chaotic, and angry. When the dadaists placed a latrine in the entryway of a gallery, it was a shocking event. Now it would hardly be noticed.

Shock and disturbance surround and engulf us. We all watched with horror as Jack Ruby shot Lee Harvey Oswald on television—A LIVE DEATH—before our eyes. Simulated death and violence are everywhere.

What we thought of as the avant-garde has become the commonplace—a titillation for the bored, entertainment for the masses in the museums and galleries.

The new avant-garde will be the antithesis and the antidote to these violent enterprises. It will not conform to trend or fashion. It will be restorative; it will create order and seek balance.

WRITING THE
SCRIPT OF ART

We must make choices based not on our likes and dislikes, but on what we should bring people to see in contemporary art. Much art is brought to the public based on what curators like or dislike. Not liking a particular work is not enough reason not to show it. You have a whole group of curators who have turned into movie reviewers and a whole group of artists who have turned into scriptwriters.

> —From a talk with Michael Botwinick,
> director of the Corcoran Art
> Gallery, Washington, D.C.

THE ART MARKET

The proliferation of art galleries and dealers is staggering. It feels like nuclear escalation. It is terrifying to think of what a commodity art has become. These days, I think about refusing to sell my work.

What if all artists refused to sell their work? Wouldn't that immediately remove art from the commodity market? Writers could expound upon and enhance it. The work could have another meaning in society.

Perhaps the world could learn from us, if we could find a way to share our work without its being marketed.

DISCUSSING THE 1985
WHITNEY BIENNIAL

The abdication of responsibility by museums is unfortunate
but nevertheless symptomatic of our society's maturation
and the ossification of its institutions, which now exist
without any knowledge of the original ideas that propelled
them into being.

> —From a conversation with Harry Rand,
> curator of contemporary art,
> National Museum of American Art,
> Washington, D.C.

THE ARTIST AND THE
CRIMINAL ACT

Do artists make visible violent acts, thereby not having to
commit the acts themselves? Are viewers then spared com-
mitting the acts by having their fantasies visualized and
thereby resolved?

MINIMALISM

The work of minimalist artists was so tightly buttoned down that there was no place for their anger to go except into their lives. Edward Lucie Smith calls it "the art of the Blocked Drain . . . an art of anger."

ATTITUDINAL HEALING
VOW FOR CRITICS *

"I will recognize that artists, writers, and musicians are making art and not war—and I will treat them accordingly.

"In my reviews I will attempt to educate and empower rather than destroy. By taking this path, I can help to create a renaissance of high art and I will surround myself with positive energy."

*To be recited every night before bed.

ANONYMOUS ART

What would art look like if artists didn't sign their names, if art became anonymous, if there were no media reporting trends?

There is no doubt in my mind that art would look entirely different from the way it does today.

THE SHAMAN AND
THE COLLAPSE
OF CLASSIC TECHNIQUES
OF ART

The shaman cures not only the individual but the entire community as well, by bringing it together and extending perimeters and boundaries. All rules are suspended during the ritual act, and a balance is created between this world and the supernatural one.

The whole shamanistic structure of our civilization fell apart with the collapse of the classic techniques of art. Just as shamanic techniques were passed on from master to student, so too were artistic techniques passed on from master to apprentice in studio workshops, academies, and *ateliers*. (Leonardo, for instance, apprenticed for many years with Verrocchio, honoring his master.) These techniques brought human beings to respect their own material plane.

The shamanic culture and classical academies have fallen apart. Individuals are inventing their own rituals, working without respect or regard for their masters, often without a knowledge of them. Art has become a form of personal remedial therapy. The academy provided a sense of belonging to something greater than oneself. Now everyone is separate, competing and desperate. This leads to the war of all against all.

Artists can act as shamans by extending their boundaries to encompass the needs and aspirations of the community. Artists can then work collaboratively, without competition, for the benefit (or healing) of the community.

RELIGIOUS ART AND KITSCH

Finally, there is a religious art movement afoot, and kitsch is included in it. However, it must be considered that there is "art-world kitsch" and "popular kitsch."

Art-world kitsch, with all its sparkle, glitter, and bangles, will not be taken seriously by "the people" out there, mainly because it is not sentimental, or because whatever sentiment it contains is covered up by a "camp," humorous, or "art world" attitude.

On the other hand, popular kitsch is not taken seriously by the art world, because it takes itself seriously and is sentimental and romantic, two attributes that are looked down upon in the current art world. This raises again the question—just who is art for?

PICASSO AS A STAR

Picasso is responsible for the contemporary role of artist as egomaniac. By scribbling, doodling, or signing his name on a napkin, he contributed to a lot of the difficulty of art today. His signature became more important than the work of art.

There was no art on the napkin.

THE NEW COLLECTIVE

Building the pyramids and the great cathedrals of Europe took many thousands of workers and a massive collective strategy.

The rise of modern psychology, which encourages individual expression and self-concern, coincides with the diminution of great collective art. The grand-scale *ateliers* of Rubens, Jerome, Couture, and others gave way to the individual artist alone in his or her studio.

Epic themes are replaced by personal notation. The striving of the individual for self-expression has brought about a totally personalized art, graffiti. It allows the printing of one's name alone to become the artistic statement "I am."

The new collective will be the individual painters, architects, and sculptors who choose to work together for a shared philosophical purpose.

THE NEW SUBJECT MATTER, A PROBLEM OF TRANSCENDENCE

Christian Renaissance art dealt with transcendent images. The Resurrection, the Ascension, the Baptism—these images were uplifting. Tintoretto, Rubens, Piero, Raphael, and Michelangelo had their imagery clearly cut out. Life and death, heaven and hell, were depicted in subjects like the Virgin Birth, the Crucifixion, the Resurrection, and the Last Judgment. Transcendence was built in; it was often almost literal.

Veronese, Poussin, and Puvis de Chavannes dealt with mythology and allegory, still an attempt to work with heroic and transcendent subject matter.

In surrealism, transcendence occurs when one shifts from the conscious object to the subconscious.

Impressionism, in dealing with the common man and common objects used in everyday life, is no longer heroic or transcendent in terms of specific objects and ideas. Transcendence is transferred from subject matter (the object) to the actual paint itself.

This leads to modernism—as exemplified by Barnett Newman and Mark Rothko—in which paint and transcendent intent are merged, and the object has disappeared. The subject matter is now the fusion of transcendence and paint.

This fusion resulted in a distancing from emotion, and encouraged a cool and dispassionate art, in which sentiment, romanticism, and passion were dismissed.

The current return to representational art brings with it new subject matter, a strong reaction to the formalist and

modernist past, and a reintroduction to emotion, through the artist's personal statement and mythology. This sets the stage for a new transcendence.

THE NEW PARADIGM

Suzi Gablik and I were discussing the increasing number of artists who are distressed and dissatisfied with the present situation. We felt that it was not a matter of destroying the present system but of empowering the artists, critic-writers, dealers, curators, and collectors so that they have it within themselves to create a new culture—to become architects of consciousness and orchestrators of society.

When enough people begin to withdraw their energy from the present system, and stop reinforcing it, a more clear-cut separation between the dominant culture and the people who have rejected it will become apparent.

All the people moving around in confusion and disease will be able to focus, to see the difference more clearly and make their choice as to which way they want to go: taking the old path of money, careerism, power, glamour, and ego, or choosing to break their addiction to fame and fortune and all the things this culture says you must have, and taking the new path of healing, vision, interconnectedness, interaction, balance, and health.

Suzi and I were introduced to each other by Dominique Mazeaud. Dominique felt we should meet each other, knowing that we held similar opinions on the need to effect changes in the world and the art world.

Dominique was for many years the director of the Modern Master Tapestries gallery on Fifty-seventh Street in New York. She left that position to devote herself full-time to the growing movement dedicated to healing the planet through art and culture. Currently she has been helping by networking, by connecting artists with related people.

—From a talk with Suzi Gablik,
author of *Has Modernism Failed?*
December 12, 1985

STUDENT / TEACHER

JOSEF ALBERS

Josef Albers was both a good teacher and a bad one. He was good because of his intense love and respect for art. He infused Yale with this feeling. He had superior vision and recognized talented students.

Albers had just left Black Mountain College to take over and revitalize the waning and old-fashioned Yale School of Art. When he arrived, he found that the students he had inherited did not understand his language—the language of modernism. He had the brilliant idea of bringing in talented students who could relate to him and infuse the school with new energy. I was one of the ones he chose. He gave me a scholarship and a studio, both of which I needed and appreciated.

I had just graduated from Cooper Union and was spending many nights at the Artists Club and the Cedar Bar. I was a wild and rebellious abstract expressionist. I had developed a technique of loading a brush with paint and flinging it onto the canvas from thirty feet away. Once I lost my grip and the brush went flying though the air, pierced the canvas, and left a gaping hole.

I wore tight button-up blue jeans, at a time when the few graduate women who were permitted to attend Yale were instructed to wear skirts. This did not appeal to the man who painted in a white suit and wanted me to wear one too.

Albers wanted me to paint squares, as he did. Painting squares was not my nature; consequently, there was friction between us. A distance was created between us . . . but a respectful one.

He could have taken my scholarship away, but he

didn't. I acknowledged him for that. I knew he respected me as an artist and I always felt the pressure of his watchful eye on my work. We had a silent but meaningful relationship. How much better if he could have used his abilities to bring out mine, rather than to try to reproduce himself. A great teacher not only teaches skills, but recognizes originality and encourages it.

STUART DAVIS

When I was a student at Yale, Stuart Davis came as a visiting artist. He walked into my studio and looked for a long time at my paintings and then began to speak. As he spoke, his cigarette never left his lips. It wobbled up and down at the corner of his mouth. I watched as the ash got longer and longer and finally flopped onto his shirt. As the cigarette burned down and got shorter and shorter, I realized that I hadn't heard a word he'd said. I was afraid that the cigarette would burn his lips, which had already turned brown from years of tobacco—life process interfering with art.

LIVE WHITE DOVES

An artwork by a graduating student at the Minneapolis College of Art and Design: several live white doves in a small white room with white netting on the ceiling. Reproductions of Rembrandt, Picasso, Courbet, the *Mona Lisa*, the *Blue Boy*, all in cheap, kitschy gold frames on the walls. There is bird excrement all over the paintings and the plaster statues on which the birds perch. I become more fascinated with the birds than with the art. They coo and fly. A sense of peace prevails. A disregard for the art. The peaceful birds couldn't care less. A beautiful event.

ARTISTS
ARE THE SHAMANS
OF SOCIETY

QUESTION: Given the difficulties connected with the life of an artist, should I continue with my career?

ANSWER: Art is a calling. It's something you do because you have to. Artists are the shamans, the priests and priestesses, the magicians of society. Only a few make a living from their art. If you have this calling, you will continue. If not, your life will gradually move toward another career. But whichever way you go, don't sacrifice your life or the quality of it. Enjoy life, live it to the fullest—whatever that may mean for you. There is something wrong when the making of art destroys the texture of your life. Don't let that happen to you. Change the context and structure in which the art is made and exhibited. Recognize that there is something wrong with the society (the "art world" as it is today) and don't lose your energy to it.

—From a lecture at
Arizona State University,
Tempe

EXHIBITING WORK

QUESTION: How can I get my work out?

ANSWER: Find new sources for exhibiting. Don't rely on the old power structure. Find new sources in the community. All artists cannot exhibit in New York City. Where you are is good. Build up your own area, particularly if there is a weak cultural community. They need you for their vision. All Italian artists did not go to Rome. There were Venetians, Florentines, Umbrians, Sienese. Regionalism is important.

—From a lecture at
the University of South Florida,
Tampa

DUCK PAINTING

QUESTION: Why are Academic Watercolor Duck Paintings selling when our own work is not?

ANSWER: (After carefully looking at their work I pointed out to them that they were all painting for a New York market, using New York color, urban dense composition, urban subject matter, all influenced by the New York gallery scene. They had totally abandoned their own beautiful state. Montana is extraordinarily open and clear, with mountains, wild animals, and its own special light.)

Paint where you are. Be where you are. Don't deny your environment. To do so will set up a conflict in your work and reduce its power. If you live in the wilderness, deal with it. If ducks fly around your studio, make a great duck painting. Look at Jan Fyt's eighteenth-century work. He was one of the great animal painters of all time.

The quality of light where you are is unique. Let it infuse your work. So is the geography, the people, the vibrations of the area.

—From a lecture at
the University of Montana,
Missoula

MAKING IT IN NEW YORK

QUESTION: Should I move to New York City?

ANSWER: If you have an uncontrollable urge to come to New York, you must do so. If it is in your nature to be there, you will stay and survive. If not, I hope you will respect yourself enough to leave.

—From a lecture at
East Texas State University,
East Commerce, Texas

COPYING

QUESTION: How do you feel about copying?

ANSWER: When I went to Music and Art High School, I saw a painting by a fellow student, which I loved. It looked like a Giacometti—multiple crosshatched lines, elongated objects. I admired the technique, the colors, everything about it. In those days, copying someone else's work was considered a cardinal sin, so I would walk past the painting trying to look casual while at the same time fervently trying to memorize it, so I could go home and secretly copy it. I really had something to learn from that painting. Later on in my education, during my days at Cooper Union and Yale, after classes I quietly copied all of the masters, Tintoretto in particular. In that way I acquired centuries of the finest teachers.

During my years of teaching, I have encouraged my students to copy the masters—I have given assignments to copy and even trace old master drawings.

If you like someone's work, tell them. If you have a need to imitate it, do it. That is all in the process of learning.

No one can take art away from anyone else. Art belongs to everyone.

—From a lecture at
the University of Bridgeport,
Bridgeport, Connecticut

ACTS OF VIOLENCE

QUESTION: Do you think acts of violence for art's sake are valid?

ANSWER: Some contemporary art has proposed injury to the artist or others—acts of violence, disemboweling of animals, self-mutilation, the destruction of objects. I do not accept any such acts as art, no matter how well documented.

<div style="text-align: right">

—From a lecture at
Syracuse University,
Syracuse, New York

</div>

THE MYTH ABOUT ARTISTS

QUESTION: Don't you think artists have to struggle to create great art?

ANSWER: There is a romantic image of the artist, drunk, dying of consumption in a garret. All that happens is you die. From cirrhosis of the liver or consumption.

Art is about life, not death. The myth about those unfortunate few who sacrificed their lives for art is probably just that, a myth. For it was the art that kept them alive. Their own psyches injured them. Rubens, Van Dyck, Michelangelo, and Leonardo were successful, healthy people who led long, full lives.

<div style="text-align: right">

—From a lecture at
the School of Visual Arts,
New York City

</div>

RETURN TO REALISM

QUESTION: Why has there been such a return to realism and photorealism?

ANSWER: There is an instinct for realism, a powerful drive to reproduce oneself. The fascination of photorealist paintings and sculpture lies partly in its apparent replication of life, but these are not merely replications. These paintings are often out of life scale, varying from over life-size to under life-size, from brilliant, heightened color to pale, undertoned hues.

So much do people want and need to see themselves and objects familiar to their existence duplicated that they don't realize that this art is, in fact, often unrealistic.

—From a lecture at
the School of Visual Arts,
New York City

ORIGINALITY

Art students often worry about losing their originality to instructors, other artists, or even themselves, through their desire to copy work they admire.

There is nothing anyone can do to take your originality away from you. You can only give it away to a bad teacher.

The mark of a great teacher is his or her ability to recognize individuality and encourage it.

> —From a lecture at Delta College, Saginaw, Michigan

RESPONSES

It is good to ask for a response to your work. While the artist is the supreme judge, it is important to consider your audience. If you are attempting to make a serious dramatic statement and your viewers only perceive something light and lyrical, you must question them to see where communication has failed and what colors or images must be changed.

Consider what audience your work is directed toward. Do you want to reach the masses or are you involved only with the New York art world? (And there are subdivisions within the art world itself: Fifty-seventh Street, Soho, Tribeca, and the East Village, to name a few.)

There are magical times when an artist produces a

poetic statement like *Finnegans Wake* that comes from an internal landscape and is directed at no particular audience.

It is important to be aware of these when you set out to work.

—From a lecture at Cooper Union, New York City

POSES

There are some poses that, even if drawn correctly, will look wrong. There are poses that are naturally easy to draw, that almost draw themselves. Similarly, there are faces and objects that just ask to be drawn, some linear, some volumetric.

When setting up a still life for a class, I avoid things like pussy willows or dried field flowers. Both have broken or unclear line, sure traps for the student. An orange, an apple, a lily, a vase are all easier to read and translate. I always try to program students for success, setting up something I know they can handle, increasing the complexity and problems as their eyes and artistic abilities grow.

HOW LONG IS
A ONE-MINUTE POSE?

There is a relationship between time and size. On the first day of my anatomy classes, I instruct the model to take one-minute poses for twenty minutes. Most students start by using the entire page. At the end of the session, they have used up half of their newsprint pad. What will they do for the next three hours? The first realization that there is a correlation between time and size occurs. One could not make a one-minute drawing fifty feet long, because it would take more than one minute to make a fifty-foot line. The concept of how much to put into a drawing, in how much time, begins to evolve in the student's mind.

At the end of the semester, my anatomy students can complete a figure containing a skeleton and all of the basic muscles in thirty seconds. Given an entire minute, they include hair on the head, pubic hair, nipples, navel, and facial features. Two minutes seem like an eternity to them.

A STUDENT'S PERSONAL VOW

I will acknowledge the work of any artists I like and will feel free to copy and imitate their work, giving full credit to their powers and recognizing what I can learn from them. I do this with joy and respect—as a form of giving.

ART OR THERAPY?

Creative expression is not art, it is creative expression.

Self-expression is not art, it is self-expression.

Rule-breaking is not art, it is rule-breaking. A new idea does not necessarily mean it is great art; it is just a new idea.

For a work to become art, it must do more than vent its spleen.

Artists have two responsibilities. The first is to express themselves. The second is to communicate. If artists don't communicate, they have either been unsuccessful in their attempt or they are being self-indulgent by not trying, unless one of those rare moments occurs when a magical poetic statement happens for oneself alone.

RULES FOR A YOUNG PAINTER

1. Always listen to the voice within you that knows the truth. If you get caught up in the anxiety of the art world, take a moment out, sit quietly, meditate if you can, and get back in touch with the voice within you that knows the truth and paint from there. (A good dealer may request, but will never tell you what to paint.)

2. Aside from cooperative artist-run galleries, be suspicious of any gallery that solicits money for a show.

3. However large or small, work in a beautiful place. A studio is a haven, a place to grow, to learn and explore, a place of light and joy.

BEING COMMERCIAL

If you can't make it good, make it big.
If you can't make it big, make it red.

FLYING WITH
PETE SEEGER

On a plane to Washington, to jury for the National Endowment Awards, dressed to the hilt, trying to look respectable, I sit next to a man in blue jeans and an orange T-shirt. I play the banjo and I'm sure I recognize a kindred spirit; yes, it is Pete Seeger. In the course of our conversation, I ask him how he responds to young musicians who ask, "How can I make it?" His answer was, "Sing for free, sing for as many different kinds of people as possible, schools, hospitals, churches, saloons, young and old. If there is such a thing as a breakthrough possible for you, this is the way, rather than sending a tape to an overly busy person like me. If you want to make it quickly, get a person of influence behind you, but the time of internship is important.

If you want to get rich, don't bother being an artist."

JURYING FOR THE NATIONAL ENDOWMENT AWARDS

DAY 1 AND MORNING OF DAY 2

As an overview, we are to see 35,000 slides in two days. No discussion about the artists is to take place until Day 3; by then we will have eliminated 90 percent of the entries. There are six jurors. We sit in a darkened room, five synchronized slide projectors flash five images at a time, ten from each artist—the atmosphere is charged.

After a thousand or more slides, I begin to make lists in an attempt to order what I am doing—it is mind-boggling. Phyla of visual themes begin to emerge. After twenty or more slides of a particular image appeared, it was identifiable as a category. The following is a list of the categories:

> Howling dogs and wolves
> Faces with pointy chins
> Interiors of one's own studio or home
> Cézanne adherents
> Houses on fire
> Awkward figures and symbols filled in with paisley and
> decorative motifs (trend art)
> Classical figures
> Paint-drippers and paint-pushers
> Dogs and cats
> Ducks in ponds
> Cutouts
> Academic watercolors
> Cows and chickens
> Dressing-table still lifes
> Flying figures (angels)
> X's and crosses (a large school)

Shrines and *thankas*
Bare breasts and body parts
Troubled early sex
Sick, wounded babies
Blue figures, yellow dogs, and red horses
Observation of the self looking in a mirror, dressing
Flowers turning into vaginas
Worms turning into penises

I noticed that the names of the artists were indicative of the subject matter they chose: the artists' real names have been changed to protect the innocent and guilty.

Lovejoy: paints people in loving and strained relationships
Sprung: paints abstract coils and twisted shapes that look about to spring
Sauer: paints objects that look pickled
Winter: paints outdoor scenes and landscapes
Cox: paints cocks
Fox: paints howling animals
Lombar: paints anatomical nudes
Small: paints scenes filled with little people
Polk: paints dotted paintings
Kind: paints people who hate each other
Assimoff: paints people with large asses
Perfecto: paints idealized icons

DAY 2, AFTERNOON
AND EVENING

I see slides of young men and women crying; bodies writhing in pain; naked figures alone in a room, in a corner or in a box; broken dolls and toy trains. Such personal sadness should be overcome.

I think of Tintoretto, and how the masters transcended their personal lives. They saw themselves in the larger scheme of things, as part of the universe. They identified with the saints, gods, and mythological characters in their paintings. Rather than seeing themselves as helpless and pathetic, they saw God in the self. They were more interested in the radiant agony of the martyrs than in a personal wound or cut.

DAY 2

I begin to feel sorry for the "Italian restaurant" fruit-and-flower painters, the duck-and-poodle painters, and the sunset-and-seascape painters. Their works are among the only ones framed, usually in a gaudy gold Renaissance style, ornamented with baroque curves and filigree. Sometimes they appear standing beside their work, smiling. But then I realize what a true sense of accomplishment they have, and how proud they are at having achieved what they set out to do. You know their friends and family all love their work. These painters have their own rewards—they are successful.

DAY 3

We have narrowed the slides down from 35,000 to approximately 350; we are now into serious business, the final eliminations. Projectors all going at once, we are six jurors, one NEA official reading the artists' names, four or five assistants, and two observers. The room is filled with drama. Loud, weighted silence—you can feel the intensity of our collective vision, eyeballs screwed tight, all focusing sharply on the panoramic screen. If the energy given off by our eyes and brains during the process of thinking, seeing, and evaluating could be measured by noise level, the room would emit continuous roaring sounds.

DAY 4

Slides of the finalists are projected, all styles, sizes, and ages. A Chicago-style artist comes up on the screen—the work looks kinky, naïve, hokey. We ask for the background and it is read aloud. We find that the artist was previously a photorealist and switched. This is clearly not an Edward Hicks, a truly naïve artist, nor does the work possess the true awkwardness of Cézanne. This is trend art, which arises neither from passion nor from inner truth.

DAY 4
STILL-LIFE PAINTERS AND ABSTRACTIONISTS

I sense the feelings of satisfaction derived by the artists who place simple objects on a table and then proceed to paint. Some include the table and the corner of their studio. I can feel the quiet observation of their set-up and the studied, meditative process of creating.

There are many abstract artists who take pleasure in the intellectual concepts of their work, as well as those who take pleasure in the application of paint and their interaction with the canvas.

DAY 5

We review all of the finalists before the eventual fellowship determinations. The slides are flashed on the screen five at a time, two sets of five for each artist. Six of us sit behind a long conference table. The images flash and change every second; it's like watching TV from your bed with an automatic channel selector, only someone else is pressing the button. The difference is that we are watching someone's entire lifework in the summation of a few seconds. I wonder what it does to our brains—the impression, implantation, and intrusion of so many life images. The responsibility for so many decisions is serious.

DAY 5

So much is who you know. In the category of fashion and trend painters, some of those rejected were as good as, or better than, the established artists they imitated. Can it be right that the ones who came first get the notoriety and monetary rewards? All it means is that there is something wrong with the system as well as the art itself. After a while they all looked alike. We bent over backwards to be fair and include unknowns.

END OF DAY 5

It has been brutal—little sleep and a fast pace. We now determine how much money each artist is to be awarded. The amounts are $5,000, $15,000, and $25,000. The highest and rarest honor is the $25,000 grant. After many queries, we are informed that last year's painting panel awarded five grants of $25,000 each. This is only to be used as a guideline. We are to make nominations based on years in the field, quality of work, professional influence of the work in the art world and on students, teaching experience, and so on. We are allowed to discuss or make a plea for those artists nominated in order to justify their receiving the award.

The $25,000 award has to be unanimous. If only one juror holds out, the grant will not go through. There ensues heavy debate, contention, and discussion. A total of 130

grants are finally recommended: forty-seven at $5,000, seventy-nine at $15,000. One juror held out. Our panel awards only four grants of $25,000.

<div style="text-align:center">IT IS OVER!!!</div>

DAY 5: LATE AFTERNOON

I walk rapidly to the East Wing of the National Gallery to see the "Sculpture of India" show. I have exactly one hour until the museum closes. I run up the stairs, into the elevator. I want up—the tower; it goes down. Pressured for time, overworked, overstimulated, I finally enter the exhibition space and am met with calm and serene buddhas, goddesses, and bodhisattvas, bestowing grace and wisdom. For the first time in a week, the tension drains from my body and I am at peace in front of these ancient statues. What a blessing. I silently thank all of those ancient sculptors and stonecarvers for the years of loving and caring—every jewel, every bead precisely chiseled and sanded.

Thank you.

DAY 6: MORNING

I leave for Philadelphia at 9:30 A.M. I feel invigorated, and both relieved and sad about separating. I'm glad it's over, yet the ending for such an intense involvement was all too abrupt. We were together for five days, from 9:00 A.M. until 11:00 P.M.—breakfast, lunch, and dinner. We probed each other's minds and sometimes hearts. There should have been some closing event—a small farewell tea, perhaps—but there was not time. We worked up to the very end, when members of the jury had to catch planes and trains to their various destinations.

I am sorry we could not award more grants. I am glad we were able to award the ones we did.

DAY 6

I think about the system of selection. We all tried to be as fair as possible and rise above our own prejudices, and yet there were so many human flaws. If you saw one good slide after twenty bad ones, it looked so much better. Some works photographed better than others; some read big when they were small, and vice versa. It always helps when a juror knows the work and can explain it. What happens to those works that need explanation and don't have it? I wonder about the whole system, exactly where the value of these grants should be placed in the broader scheme of the needs of people in the entire country. Still, I am truly pleased about having participated. In spite of the flaws inherent in the jurying system, I am happy to have been able to help other artists.